forever friends

by Nancy Bohlen

Meredith® Press
New York

ACKNOWLEDGMENTS

I would like to extend special thanks to my staff at The Cornell Collection. Their tireless support and cheerful willingness to work overtime are invaluable contributions to the production of our original patterns such as the wonderful dolls in this book, as well as all of our cross-stitch and needlecraft designs.

Photography: Woody Smith
Setup and design: Anita Mitchell
Designers: Cindy Kaiser and Amy Bloom

Meredith® Press is an imprint of Meredith® Books
President, Book Group: Joseph J. Ward
Vice President, Editorial Director: Elizabeth P. Rice

For Meredith® Press:
Executive Editor: Maryanne Bannon
Senior Editor: Carol Spier
Associate Editor: Ruth Weadock
Assistant: Ruth Rojas
Copyeditor: Linnea Leedham Ochs
Production Manager: Bill Rose
Design: Ulrich Ruchti
Cover Photography: Steven Mays

Copyright © 1994 Nancy Bohlen
Distributed by Meredith® Corporation, Des Moines, Iowa
Printed in the United States of America
10 9 8 7 6 5 4 3 2

ISBN: 0-696-02397-0
First Printing: 1994
Library of Congress Card Catalog Number: 93-077498

All of us at Meredith® Press welcome your comments and suggestions so that we may continue to bring you the best crafts products possible. Please address your correspondence to Customer Service Department, Meredith Press, 150 East 52nd Street, New York, NY 10022 or call 1-800-678-2665.

TABLE OF CONTENTS

DEAR CRAFTER:

If ever there was a gift that says "I love you" to a child or a dear friend, it must be a soft, stuffed doll or animal, handmade by the giver. The country-inspired padded pals in *Forever Friends* make charming collectibles, "get-well" pick-me-up's, or presents for young ones who'll cherish the memory of a bear, a bunny, or a beautifully bedecked doll long after she has become threadbare from cuddling.

Each of these projects feature clear, step-by-step directions and full-size patterns with seam allowances, accompanied by inspirational full color photographs. There's even a helpful "Basics" chapter to get you started.

As you stitch a Forever Friend for someone special, watch it come to life with the love that is part of any handmade gift passed from friend to friend.

—MARYANNE BANNON, Executive Editor

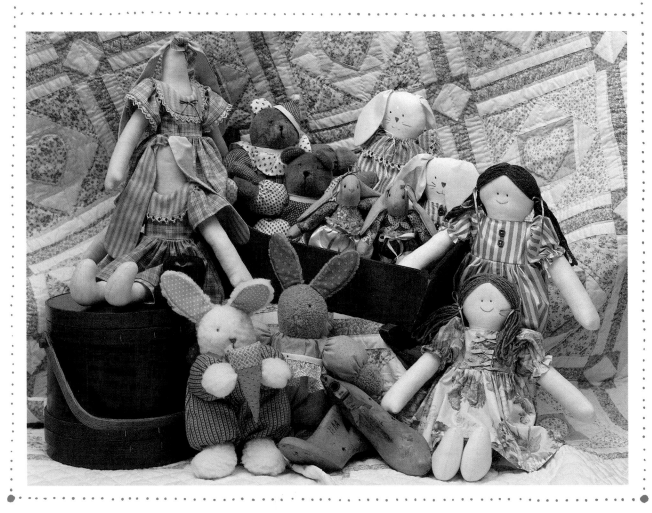

INTRODUCTION

When I remember playing with dolls as a little girl, I recall the personalities I gave
them, the special clothing I made for them, and how much I loved each one.
In creating these dolls I've tried to capture some of those special childhood
times.

Have fun with the dolls you make. Place them on a kitchen window sill, a bathroom
shelf, your mantel, or in a basket. Pose a bunch around a small Christmas
tree for a great centerpiece at holiday time. Make a small doll and sit her
on top of a wrapped present. Wouldn't a child you know love to have a doll
to carry around? (Remember to use embroidered or drawn faces on dolls
for young children.) Whip up a few tiny dolls for your favorite teachers,
neighbors, and friends. Everyone appreciates the bit of you that goes into a
lovingly made creation.

As you personalize these dolls for yourself and others, I hope that the fantasies and
innocence of youth will be rekindled and that each doll will become a
cherished friend.

—NANCY BOHLEN

GENERAL INSTRUCTIONS AND TIPS

These basic guidelines apply to all the projects in this book. Any exceptions are
clearly noted.

Fabric I use only 100% cotton fabric whenever possible, as it "cooperates" best
during pressing and sewing. Perhaps most importantly, I find it prettier than
blends or synthetic weaves, producing an even more appealing finished look
after all that hard work!

The width for all fabrics is 44″–45″ unless otherwise noted.

Patterns Use tracing paper to trace all pattern pieces from the pages of the book. Cardboard templates are more durable than tracing paper patterns when you are making more than one doll. In this case, trace the patterns onto lightweight cardboard. Place the cardboard template on your fabric and trace around it in pencil to make a cutting line to follow. When appropriate, be sure to cut pieces in pairs, so that you have a right and left of each.

For patterns that are on the fold, simply fold a sheet of tracing paper in half, place it on the fold, trace, and cut. Don't forget to mark all appropriate symbols on the patterns.

Because the size of the book does not accommodate some of the larger patterns, these patterns are marked for overlaps. You will need to note the dotted lines when tracing the pieces and be sure to match them correctly when joining both parts of a pattern.

Tea-dyeing If you want your dolls to have an antique look, you can stain the body fabric with tea before cutting it. Cotton fabrics take the stain best, but you may be able to darken a blend somewhat. Simply make a saucepan of tea and soak the fabric in it. The stronger the tea and the longer the soaking time, the darker the stain will be. Hang up the fabric and let it dry thoroughly before cutting out the pattern pieces.

You can also dye fabric with coffee, which produces a darker tint, but it leaves a strong odor.

Seams For all body seams, use 12 to 15 stitches per inch, and go slowly around curves. Clip curves and trim seams in tight places before turning the fabric.

Unless otherwise noted, ¼″ seams are called for throughout.

Whipstitching When whipstitching doll body parts closed, I use strong thread that will not easily tangle or break. Button and craft threads are perfect.

Turn ¼″ of the fabric to the inside and press. Insert a needle at a right angle and close to the edge, picking up only a few threads of the fabric. The space between the stitches can be short or long depending on the location of the opening.

Gathering To gather, weave the point of the needle in and out of the fabric several times, leaving the thread long enough at the ends to pull them. Then pull

both ends while pushing the fabric into a loosely bunched gather. Secure the threads in a knot.

Basting Hand basting is used to temporarily hold together two or more layers of fabric. Simply take several evenly spaced stitches onto the needle, then pull the thread through the fabric.

Casings A casing is a tube made at the fabric's edge to enclose elastic or a drawstring. Turn ¼″ of fabric to the inside and stitch at the required distance from the folded edge.

To insert elastic into the casing, attach a safety pin to one end of the elastic. Sew the other end to the garment so it will not be pulled through. Push the pin through the casing, being careful not to let the elastic become twisted. To join the ends, overlap them and stitch them together.

Stuffing Each project calls for polyester fiber stuffing. To get a great-looking, nicely shaped doll, it is important to use a high-quality polyester fiber stuffing and to stuff evenly. A wooden dowel, about ⅜″ in diameter, comes in handy when stuffing. Sand the end to make it smooth. Use small amounts of stuffing material and push it into the doll until the stuffing is snug. Most dolls need to be stuffed fairly firmly.

Doll faces Use your imagination! But practice on a scrap of fabric before attempting the doll's face.

If you wish, you can embroider the face. Or take the easy way and use paint or a fine-tip permanent marking pen. Your local craft store can help you select a suitable pen. It is especially important to try out the pen on a piece of scrap to be sure the ink will not bleed.

To paint perfectly round dot eyes, use a small stick or the "plain" end of a small crochet hook. Dip the tip in paint and touch it to the face where desired.

To give dolls a healthy glow, you can apply powdered blush to the cheeks. A fluffy paint brush works well for small dolls, and a make-up brush is fine for larger dolls. You could even use a cotton swab in a pinch. A little blush goes a long way, so it is best to start with a small amount and add more as needed. Again, perfect your technique on some scrap material before

attempting the doll's cheeks. For children, stitch on the eyes, rather than using beads.

Hair Don't be afraid to experiment with hair as well. Many kinds of yarn make terrific-looking doll hair. You may wish to use a hot-glue gun to attach the yarn to the doll's head, or you can tack it in several places. Use your discretion for hair, keeping in mind the age of the child who will receive the doll.

Using a hot-glue gun A hot-glue gun is frequently called for in the projects. Follow the manufacturer's instructions for safe and effective use.

Closures Some dolls have different outfits and you may wish to change them. Where I call for tacking clothing together, you can instead sew on snaps or hooks. If you prefer, Velcro works well. Follow the manufacturer's instructions to attach it.

Washing dolls and clothing If you plan to give any of the dolls to children, and will thus need to wash the dolls at a later date, wash and iron all fabrics before cutting out the patterns. Apply stain repellent to the fabric to make spot cleaning by hand easier later on.

Appliqué To appliqué, cut out the necessary fabric pieces. Pin them in place or attach them with fusible webbing, following the manufacturer's instructions. Using a short, medium-width zigzag stitch, machine stitch around the raw edges of the appliqué. Go slowly to be sure to completely cover the raw edges.

Stenciling Cut a template from Mylar® or acetate. Using acrylic paint and a stencil brush, apply a light coat of paint to get the desired look.

Often you can hold the pattern piece up to the light and lightly trace the outline directly onto the fabric. Use a colored pencil to fill in the area. In either case, practice first on a scrap of fabric.

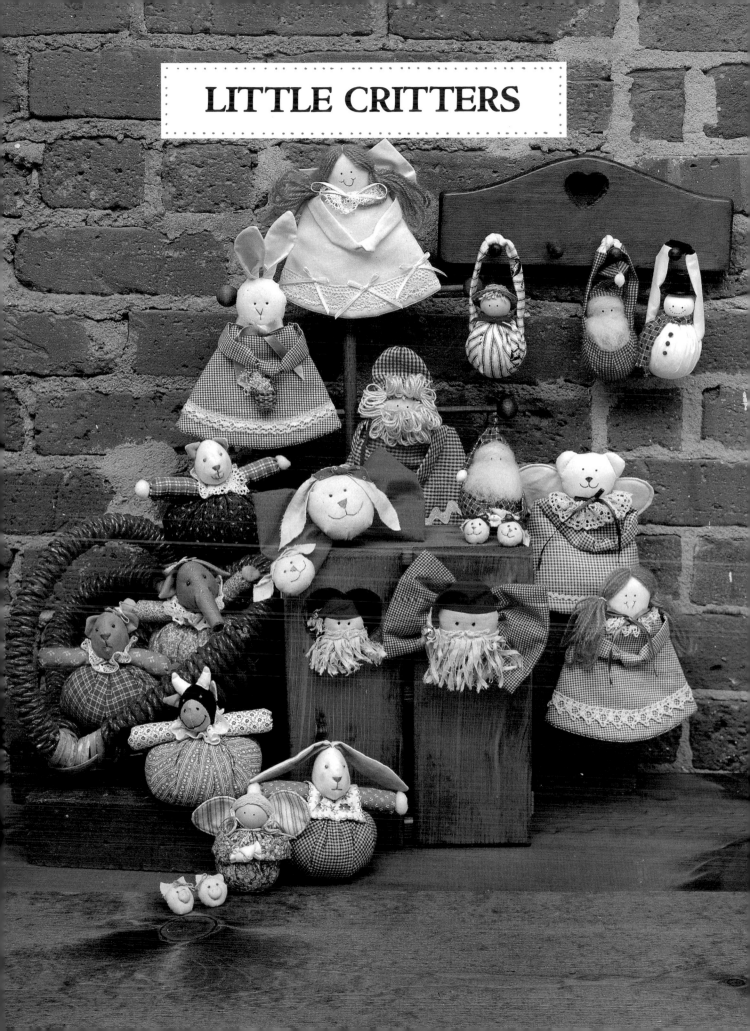

LITTLE CRITTERS

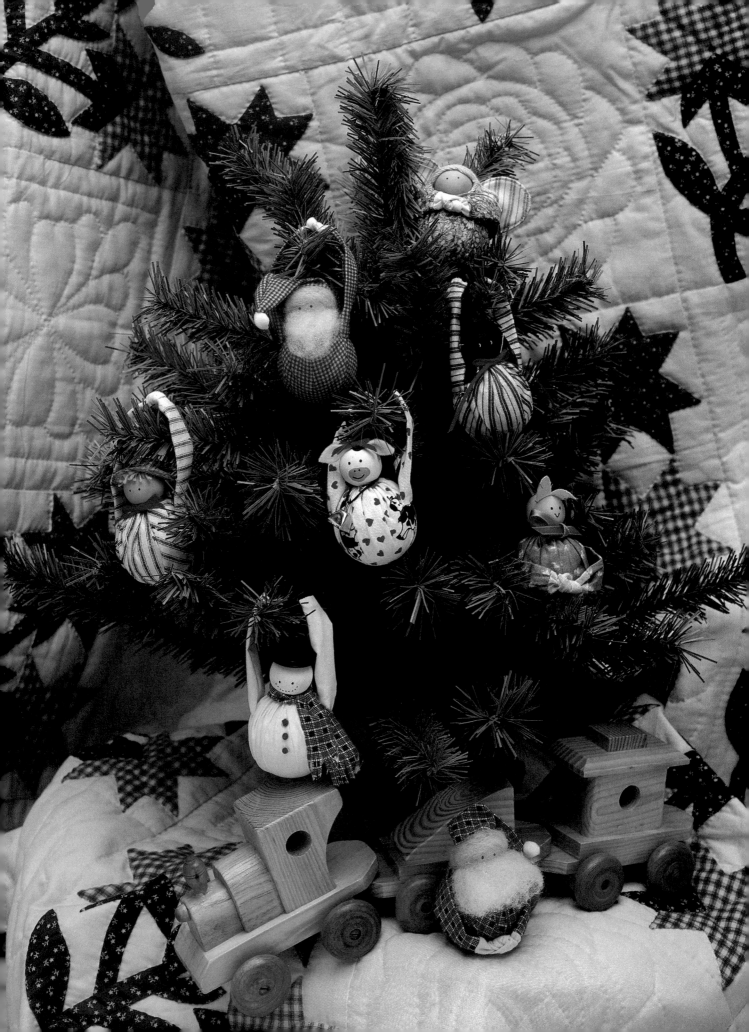

THE HANG-UPS

These chubby, cheerful ornaments can be hung on a tree, a peg, or a small knob or, if the bases are flattened, they can be placed on a shelf or mantel. Wherever you put them, they'll add a special decorative touch to your home. Each Hang-up is approximately 3″ tall.

Supplies for each Hang-up

♥ 7″ × 14″ piece of fabric for doll's body and arms
small piece of fabric for hands
2″ diameter Styrofoam ball
1″ diameter wood ball knob
acrylic paint: beige, black, white, peach
black, fine-tip permanent marking pen for faces
matching thread
powdered blush for cheeks, if desired
hot-glue gun and glue
tracing paper

Girl embroidery floss *or* crochet yarn for hair
9″ of narrow lace *or* 12″ of narrow ribbon for bow around neck

Angel embroidery floss *or* crochet yarn for hair
9″ of narrow lace *or* 12″ of narrow ribbon for bow around neck
5″ of stiff 1¼″ ribbon for wings *or* 5″ × 6″ scrap of fabric and small scrap of stiff interfacing for fabric wings

12″ of 1/16″ ribbon to tie wings onto doll

Boy embroidery floss *or* crochet yarn for hair
1½″ straw hat
9″ of narrow ribbon for bow tie

Bunny small scrap of muslin for ears
small scrap of fusible web
9″ of narrow lace *or* 12″ of narrow ribbon for bow around neck

Snowman scrap of fabric for scarf
3mm red pom-poms
28mm black plastic top hat

Santa ¼″ white pom-pom for hat
beige *or* white wool for beard and
trim on hat

Cow tiny (15mm) cowbell
12″ of ⅟₁₆″ ribbon
scrap of white felt for ears
6″ (or desired length) of narrow
ribbon for bow on head

To make each Hang-up Cut out 1 body piece. Gather the outside edge of the
circle with a running stitch. Lay a Styrofoam® ball inside the circle and pull
up the thread to enclose the ball in fabric.

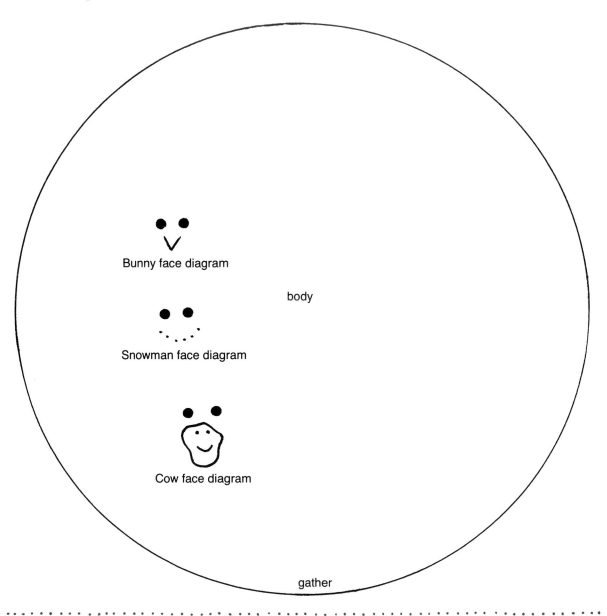

Bunny face diagram

body

Snowman face diagram

Cow face diagram

gather

Paint a wooden head the appropriate color for the Hang-up you are making, e.g., a white head with black spots and a peach nose for the cow. Using the permanent marking pen, add eyes, snowman face, or bunny face. Brush powdered blush on the cheeks, if desired. Use white paint to make eyes on a black doll. Using the hot-glue gun, glue the head on top of the gathered fabric. The head should be glued directly to the Styrofoam® ball.

Cut out 1 arm piece and 1 hand piece. Cut the arm in half, as indicated on the pattern. Using a ¼″ seam and with right sides together, stitch one of the arm pieces to each end of the hand piece. You will have a long, skinny piece with the hand piece in the middle. Fold the arm in half lengthwise, with right sides together, and stitch along the long edge. Turn right side out. Make an overhand knot at the center of this piece. Turn in ¼″ on each end of the arms, and tack each end to one side of the ornament with the arms overhead.

cut here

arm

sew arm here

hands

sew arm here

If you want your ornament to sit rather than hang, slice off a section of the Styrofoam® ball with a knife and place the flat side down in the fabric circle. Cut ½″ off the end of each arm and tack the ends at the back of the body so that the arms hang nicely in front.

Girl For her hair, make loops with embroidery floss or crochet yarn by wrapping the strands around a 3½″ piece of cardboard; 8 or 10 loops should be enough. Tie the loops with thread about 1″ from each end. Glue the hair to the head. Gather the narrow lace and fasten it around the neck, tacking it together at the back; or tie ribbon around the neck.

Angel Follow the directions for making the girl. The wings can be made from 1¼″ wide ribbon. Gather the ribbon in the center and glue it near the base of the head in back. Alternatively, the wings can be made from cloth using the heart-shaped pattern provided. Cut two heart shapes from fabric and one from stiff interfacing. Put the right sides together with the interfacing underneath and stitch the wings, leaving an opening to turn them right side out. Clip the curves. Turn right side out and press. Topstitch near the edge. Using 12″ of ¹⁄₁₆″ ribbon and a heavy needle, put the ribbon through the wings where indicated and tie it around the neck.

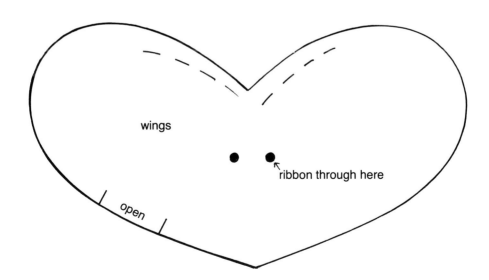

Boy Cut a few short pieces of yarn or floss for hair. Glue this to the top of the head. Glue the straw hat on the head. Tie the bow tie around his neck.

Bunny Gather the lace and fasten it at the neck by sewing the ends together; or tie a narrow ribbon around the neck. Using fusible web, fuse two small pieces of muslin together with an iron, according to the manufacturer's directions. Cut out the ears, fold under ⅛″ at the base and press to form a tab. Glue the ear tabs to the top of the head. If you want to make an angel bunny, make wings as described above.

Bunny ear

Snowman Cut a strip of fabric ¾″ × 7″ for the scarf. Make cuts close together at a 1″ depth on each end for fringe. Tie the scarf around his neck, gluing it down if necessary. Glue the small red pom-poms to the front of his body. Glue on the hat.

Santa Cut out two hat pieces from the body fabric. With right sides together, stitch, leaving the bottom open. Turn and fold ¼″ to the wrong side of the open end. Sew a white pom-pom to the end of the hat. Glue the hat to his head. Glue a strip of wool around the edge of the hat for trim. Glue wool to the chin for his beard, saving a tiny bit for a mustache, if desired.

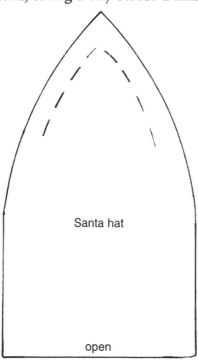

Santa hat

open

Cow Paint random black spots on the head, and a peach nose area. Cut out felt ears. Fold them in half and glue them to the top of the head, pointing out to the sides. Tie the ribbon into a small bow and glue it to the center top of her head. Tie the cowbell around the cow's neck.

Cow ear

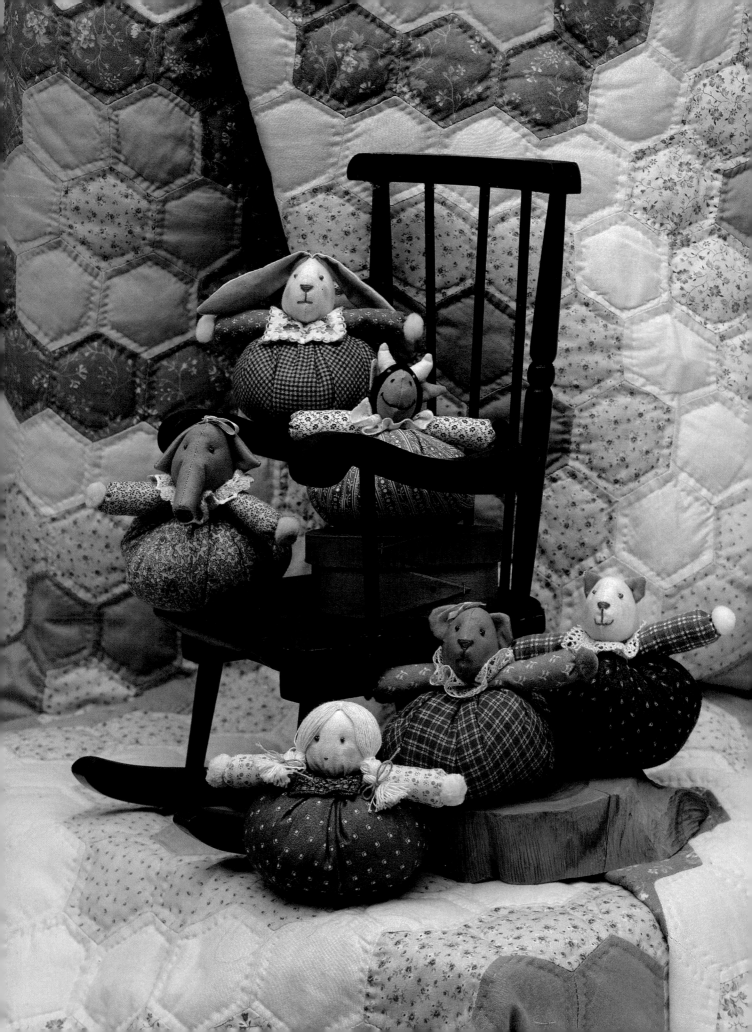

MUFFINS

Plump and friendly, these cuddly, 4″-tall dolls are perfect for toddlers to carry around under an arm. When they're at rest from playtime, Muffins are happy to settle on a child's bed, on a window seat, or in your favorite rocking chair.

Supplies for each Muffin

♥ 9½″ square of print cotton fabric for body
6″ square of different print cotton fabric for arms
12″ of ⅝″- to 1″-wide trim for collar (lace or embroidered ribbon)
2 small (½″) pom-poms for hands
2 seed beads for eyes
powdered blush for cheeks, if desired
polyester fiber stuffing
embroidery floss: black, brown, pink

Cat or bunny 7″ × 10″ piece of muslin for head
 4″ square of pink fabric for ears

Girl 3″ × 6″ piece of cotton fabric *or* muslin for head
 1 skein of cotton string *or* embroidery floss for hair
 12″ of cotton string *or* embroidery floss for braid ties

Elephant 6″ × 7″ piece of gray fabric for head
 scrap of pink fabric for ears
 scrap of gray felt for nose
 small bow made from thin ribbon

Bear 6″ square of tan fabric for head
 scrap of pink fabric for ears
 small bow made from thin ribbon

Cow 3″ × 6″ piece of pink fabric for
head front
scrap of black fabric for head
back
scrap of muslin for horns

To make each Muffin's body Cut 1 body piece on the fold. Gather the outside
edge and pull the threads to form a pocket. Stuff plumply with polyester
fiber, pull the gathering threads tight, and secure by tying them.

Cut 1 arm piece. Fold lengthwise with right sides together and stitch the long edge.
Turn right side out and stitch the center of the arm piece to the top of the
muffin body. Stuff each arm, turn in ¼″ on each end, gather, and close.
Tack a pom-pom to each arm.

arms

To add lace neck trim, gather the lace tightly and sew it to the top of the arms. To
add ribbon neck trim instead, fold the ribbon into a square centered around
the top of the body, making a neat fold at each corner. Sew the ribbon in
place.

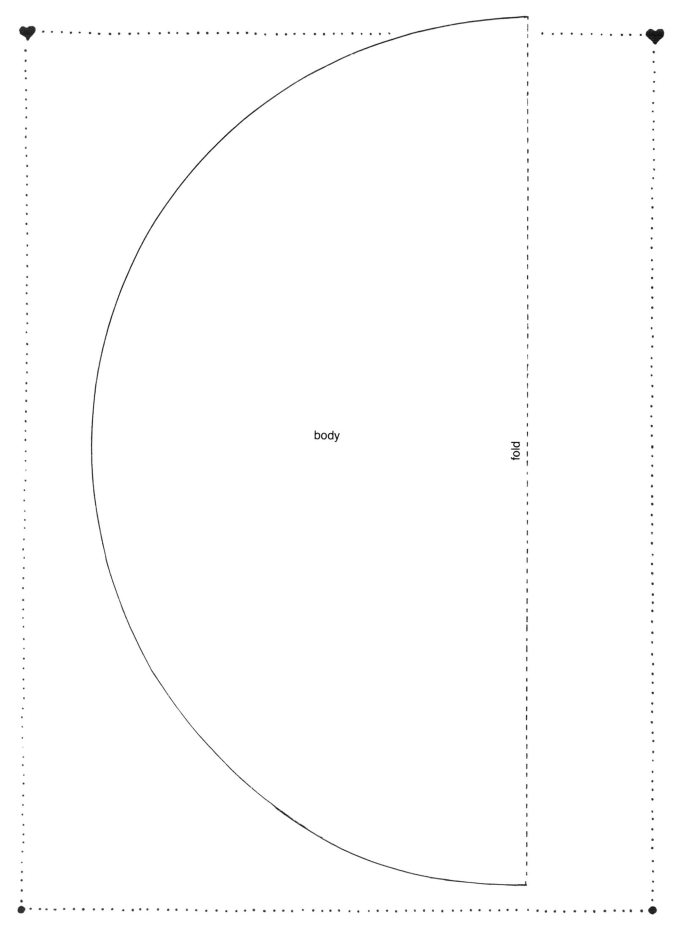

body

fold

Bunny Cut 2 pink ear pieces, 2 muslin ear pieces, and 2 muslin head pieces. With right sides together, stitch the muslin ears to the pink linings, then turn them right side out. Fold the sides to the center and pin them in place where indicated on the head pattern. With right sides together, stitch the head pieces together, leaving the neck open. Turn right side out and stuff. (The ears should flop down at either side of the head.) Gather the open edge, close, and sew the head to the top of the Muffin body. Sew seed beads to the head for eyes, pulling the threads slightly to indent them. Apply powdered blush to the cheeks, if desired. Use 3 strands of floss to make a triangular satin-stitch nose.

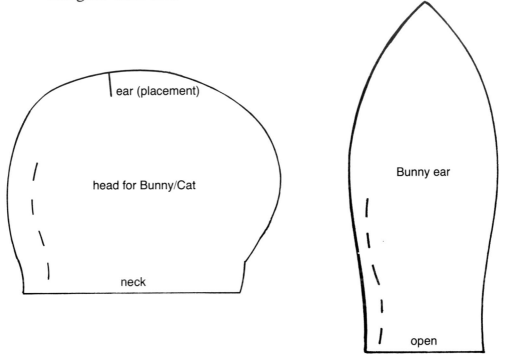

Cat Follow the directions for the bunny, with one exception: Whipstitch the ears on after the head has been stuffed.

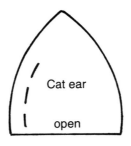

Bear Follow the directions for making the cat. After sewing the head pieces and with the right sides still together, bring the seams together at the nose and stitch across the nose, ⅛″ from the nose tip edge, to give it a flatter appearance. (See Figure 1.) Add a bow to one ear.

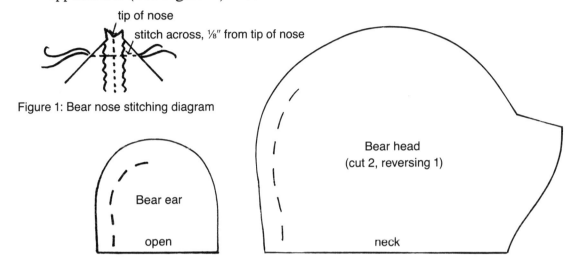

tip of nose

stitch across, ⅛″ from tip of nose

Figure 1: Bear nose stitching diagram

Bear ear
open

Bear head
(cut 2, reversing 1)

neck

Elephant Cut 2 head pieces and 2 ear pieces from gray fabric, and 2 ear pieces from pink fabric. With right sides together, stitch the head pieces together,

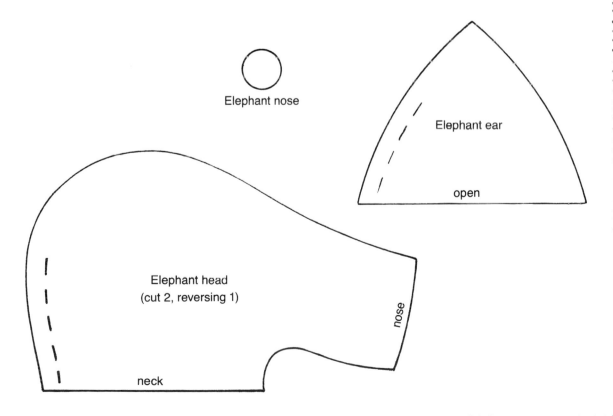

Elephant nose

Elephant ear

open

Elephant head
(cut 2, reversing 1)

nose

neck

leaving the neck and the end of the nose open. Turn right side out and stuff. Turn under ¼″ at the nose edge. Cut a gray felt circle and sew or glue it over the opening at the end of the trunk.

With right sides together, sew the pink linings to the gray ears. Turn right side out and whipstitch them to the sides of the head. Gather and close the neck of the head as described earlier, and sew the head to the top of the body. Add a bow to the top of the head. Sew on bead eyes, as for the bunny.

Girl Cut 2 head pieces. Stitch the pieces together with right sides together, leaving the neck open. Turn the head right side out, stuff it, and gather and close the neck. Sew the head to the top of the Muffin body.

Sew beads to the head for eyes and form the mouth by making one small straight stitch with the color embroidery thread desired. Brush powdered blush on the cheeks.

To make the hair, wrap the string around a 5″ piece of cardboard about 40 times. Clip through one end of the strands. Spread out the 10″ strands to measure 2½″ wide. Machine stitch across them several times to form a center part. Sew the hair to the center of the head. Combine the strands on each side and braid the hair, tying each braid with embroidery floss or string. Trim the braids. For an extra touch, you may want to attach a fabric flower to the top of the head.

Cow Cut 2 black ear pieces, 2 pink ear pieces, 4 muslin horn pieces, 2 black back head pieces, and 2 pink front head pieces. Matching the straight edges, sew the head fronts to the head backs. Then with right sides together, stitch the completed head pieces together, leaving the neck open. Turn the head right side out and stuff. Gather the neck edge, pull the opening closed, and whipstitch the head to the Muffin body.

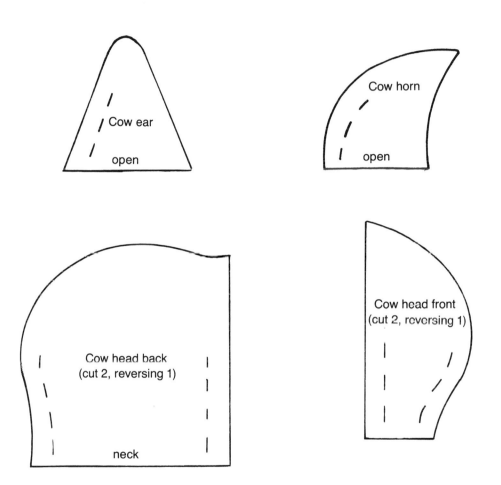

With right sides together, stitch the pink ear linings to the black ears, turn right side out, and sew the ears to the sides of the head.

Sew the horn pieces, right sides together. Turn them right side out, stuff them, and sew them to the head. Sew on bead eyes and stitch the mouth, as described for the girl.

BUTTONS 'N' BOWS

Add a touch of whimsy to your wardrobe and sunshine to your day with these anything-but-ordinary accessories. Make some extras for friends—they're perfect stocking stuffers or gift-tag embellishments.

Before beginning, read through all the directions and decide which Buttons you wish to make. Buttons can be made in three sizes and used for a wide variety of accessories. See the suggestions for sizes to make hair bows, pins, tie pins, shoe clips, and earrings.

Supplies for all Buttons

♥ scraps of cotton fabric for basic Button, animal ears, and Santa's beard
quilting thread
matching thread
polyester fiber stuffing
powdered blush for cheeks, if desired
hot-glue gun and glue

Bunny or Piggy embroidery floss: pink, brown, coordinating color for bow

Annie embroidery floss: red, black, rust, coordinating color for bow
scrap of red cotton fabric for large Button's hair
white glue
black, fine-tip permanent marking pen for face

Santa 5″ square of red cotton fabric for hat
jingle bell: 6mm for small and medium Santas, 10mm for large Santa
black embroidery floss

Button backings For small Buttons: earring sets (clip-ons or pierced)

For medium Buttons: pin backs, tie pins, small (2½″) hair clips, shoe clips, 8″ square of fabric and 3″ × 4″ piece of fleece for each hair bow

For large Buttons: large (3″) hair clips, 12″ square of fabric and 4½″ × 6″ piece of fleece for each hair bow

To make each Button Cut out 1 Button piece from your fabric. Using a double strand of quilting thread, run the thread around the outside edge of the circle, about ⅛″ inside the raw edge. Put a small amount of stuffing into the circle, pull up the threads and knot them several times. You may have to experiment with the amount of stuffing. The Button should be firm enough to hold its shape, but not hard.

Flatten out the Button with your hand. Using 2 strands of embroidery floss, follow the diagrams provided to stitch the appropriate face on your Button. Use French knots for all eyes: 2 wraps for the small Button, 3 wraps for the medium Button, and 4 wraps for the large Button. Brush powdered blush on the cheeks, if desired.

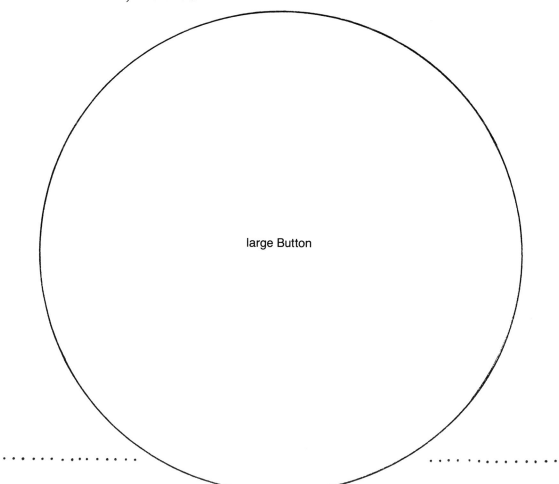

large Button

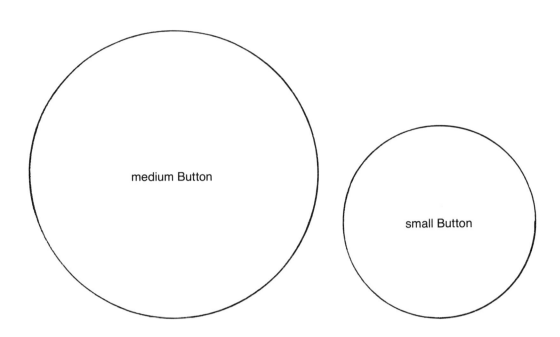

Bunny Use the appropriate size pattern to cut out 1 ear piece. Tie an overhand knot in the center. Brush a small amount of blush on the inside of the ears to make them slightly pink, if desired. Tack the ears to the top of the head. Make a bow from coordinating floss and tack it in front of the ears.

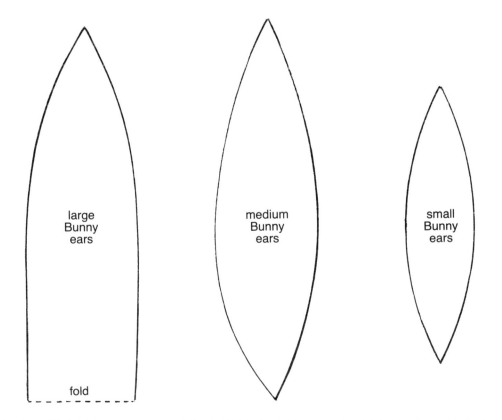

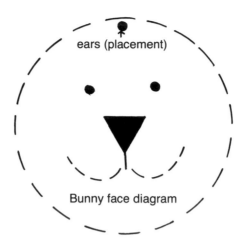

ears (placement)

Bunny face diagram

Piggy Before you embroider the eyes and mouth, make the snout by cutting out the appropriate size snout piece and gathering it as you did the Button itself, using a small bit of stuffing and flattening out the nose. Tack the snout to the center of the face with two small stitches of quilting thread (these stitches form the nostrils).

Cut out ears and tack or hot-glue them to the back of the Button. Make a small floss bow and tack it to the front of the head.

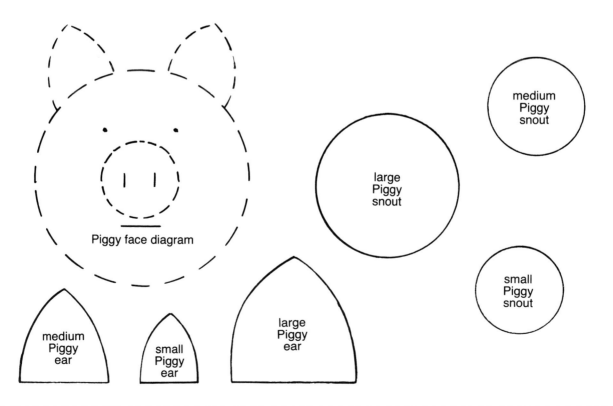

Piggy face diagram

medium Piggy snout

large Piggy snout

small Piggy snout

medium Piggy ear

small Piggy ear

large Piggy ear

Annie Embroider the face. Add freckles with a black, fine-tip permanent marking pen, if desired. Make hair for the large Button by ripping skinny scraps of red cotton. Cut these about 4″ long. Put 2 pieces together and tie a knot in the center. Pull the layers apart to fluff the fabric and glue or tack the knots all around the top and sides of the head. Trim the hair to the desired length.

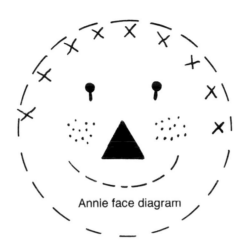

Annie face diagram

To make hair for the other Buttons, cut lengths of floss 2″ long for the small Button and 3″ long for the medium Button. Thread a needle with floss and run it through the sides of the face where indicated on the diagram. Knot each section a couple of times with an overhand knot. Add as many threads as you wish to get the desired fullness. To make the hair stiff enough to stand out, I put a small amount of white glue on my fingers and rub it on the hair. (The glue dries clear.) Trim hair to a length you desire. Tack a bow to the head, if you wish.

Santa Make the beard after you make the eyes and blush the cheeks. Cut the piece of beard fabric to measure 1⅛″ × 3″ for the small Button. Fold this piece in thirds so it measures 1⅛″ × 1″. Stitch across one 1⅛″ edge to keep all of the layers together. Fold the stitched edge under and stitch or glue this edge to the face where indicated. Clip the beard with small, very sharp scissors every ⅛″ to make it ragged. Cut a few skinny strips of fabric to use as a mustache and tack them above the beard. (The medium Santa's beard requires a 1¾″ × 4½″ piece of fabric; the large Santa's beard, a 2″ × 9″ piece. Follow the same procedure as for the small Santa's beard.)

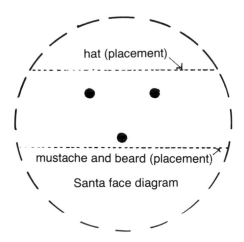

hat (placement)

mustache and beard (placement)

Santa face diagram

For Santa's hat, cut out the appropriate size hat piece. Hand or machine stitch the center back seam. Fold under ⅛″ around the hat's edge to the wrong side and put the hat on Santa. Tack the hat all around the head. Make a small pom-pom for the hat using a few skinny strips of beard fabric tacked to the end of the hat. If desired, tack a small jingle bell over the pom-pom.

large Santa hat

medium Santa hat

small Santa hat

To finish Buttons 'n' Bows

EARRINGS Using a hot-glue gun, glue a small Button to a purchased clip or pierced earring set.

TIE PIN Glue a medium or small Button to a purchased tie-pin set.

PIN Glue a small or medium Button to a purchased pin back.

SHOE CLIPS Glue or tack a medium or small Button to a purchased shoe-clip set.

HAIR BOW To make a large hair bow with a large Button, cut a piece of fabric $4\frac{1}{2}'' \times 12''$. Also cut a $2'' \times 3\frac{1}{2}''$ piece to gather the bow at the center. Cut a piece of fleece to measure $4\frac{1}{2}'' \times 6''$. Fold the cotton fabric in half widthwise, with the right sides together, and place it on top of the fleece. Stitch the sides, leaving an opening near the center. Turn the bow right side out. Fold the long edges of the $2'' \times 3\frac{1}{2}''$ piece to the center. Gather the center of the bow, wrap the small piece of fabric around it, and tack. Glue a large Button to the center of the bow. Glue the bow to a large (3″ long) purchased hair clip.

To make a smaller bow for a medium Button, follow the same procedure using an $3'' \times 8''$ piece of fabric, a $1\frac{1}{2}'' \times 2\frac{1}{2}''$ piece of gathering material, and a $3'' \times 4''$ piece of fleece. Glue the Button 'n' Bow to a $2\frac{1}{2}''$ purchased hair clip.

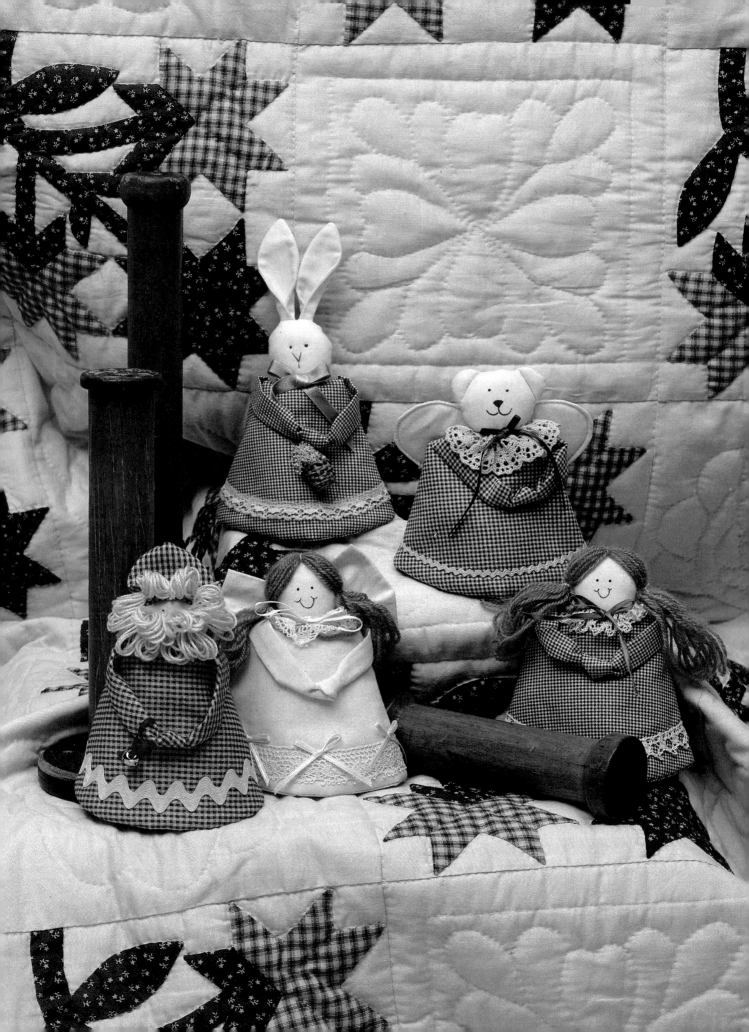

ROUNDABOUTS

With hands clasped peacefully, the Roundabouts lend a comforting air to any room they're placed in. These full-skirted, 6″ tall dolls resemble small-scale tea cozies, and will happily camouflage small containers or stand on their own with ease.

Supplies for each Roundabout

♥ 5″ × 35″ piece of cotton fabric for body and arms

5″ × 12″ piece of fleece for inner body

small amount of polyester fiber stuffing for head

matching thread

powdered blush for cheeks, if desired

hot-glue gun and glue

black, fine-tip permanent marking pen for faces (except bunny)

Bunny 4″ × 8″ piece of cotton fabric for head

15″ of gathered ⅝″ wide lace

9″ of ¼″ ribbon for bow around neck

pink and brown embroidery floss

small basket (optional)

Bear 4″ × 8″ piece of cotton fabric for head

15″ of baby rickrack

12″ of 1″ wide lace for neck

12″ of ⅛″ wide ribbon for bow around neck

7″ × 8″ piece of fabric for wings

4″ × 7″ piece of fleece for wings

Girl 4″ × 8″ piece of cotton fabric *or* muslin for head

1 yd. of flat ⅝″ wide lace

1″ piece of lace for neck

12″ of ⅛″-wide ribbon for bow around neck

1 skein of crochet yarn for hair

Angel same supplies as for Girl

½ yd. of ribbon for bows on front of dress

7″ × 8″ piece of fabric for wings

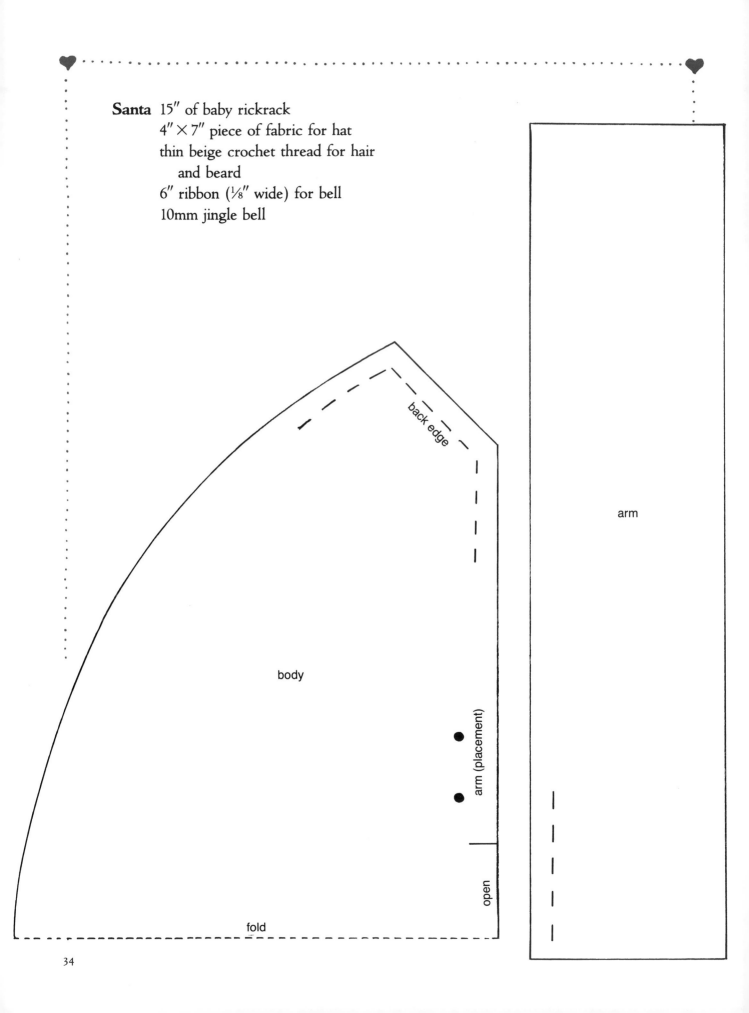

Santa 15″ of baby rickrack
4″ × 7″ piece of fabric for hat
thin beige crochet thread for hair
and beard
6″ ribbon (⅛″ wide) for bell
10mm jingle bell

back edge

arm

body

arm (placement)

open

fold

To make each Roundabout's body With the pattern on the fold, cut out 2 body pieces from cotton fabric and 1 from fleece. Cut out 1 arm piece. With right sides together, fold the arm piece lengthwise and stitch down the long edge, leaving the ends open. Turn the arm right side out and make an overhand knot in the center.

On the right side of one of the body pieces, stitch rickrack or lace 1″ up from the raw edge. Place the ends of the arms on the wrong side of the body pieces where indicated on the pattern. (Note: Only one arm placement is indicated. The other arm end should be placed symmetrically on the opposite side of the fold line after cutting.) With the 2 body pieces right sides together, and fleece underneath, stitch all around the body, leaving an opening where indicated on the pattern. Trim the seams, turn right side out, and press. Overlap the back edges about 1″ and tack them together.

Bunny Cut out 2 head pieces and 4 ear pieces. With right sides together, stitch the ear pieces. Turn them right side out, fold the sides to the center, and pin them in place where indicated on the head pattern.

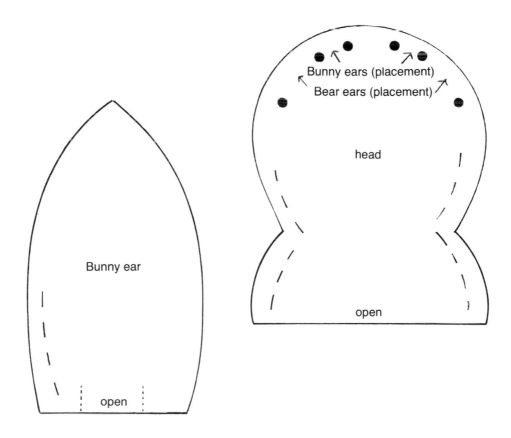

Bunny ears (placement)

Bear ears (placement)

head

Bunny ear

open

open

With right sides together, stitch the head pieces, leaving an opening where indicated on the pattern. Stuff the head lightly, and place the "neck" into the opening in the body. Tack the head in place through the front and back layers, closing the opening.

Using 3 strands of embroidery floss, sew on the bunny's face according to the diagram. Make a bow from the ribbon and tack it under the bunny's chin. Tack a small basket to the knotted hands, if desired.

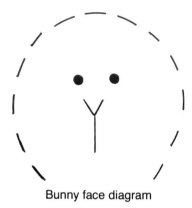

Bunny face diagram

Bear Follow the directions for making the bunny head, but use the pattern for the bear ears and leave the ears flat before pinning them into the place indicated on the head pattern. Follow the diagram to draw the bear's face. Gather the lace and sew or glue it around the bear's neck. Make a bow from the ribbon and tack it under the chin.

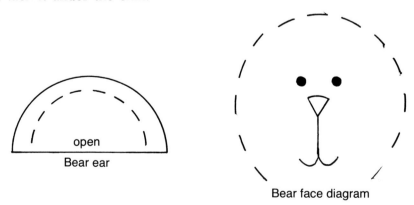

open
Bear ear

Bear face diagram

To make the heart-shaped wings, cut out 2 fabric heart pieces and 1 fleece piece. With right sides together and the fleece underneath, stitch around the edges, leaving the opening where indicated. Turn the wings right side out, press them, and edgestitch, if desired. Tack the wings to the base of the bear's head.

Girl Again follow the directions for making the bunny head, omitting the ears. Follow the diagram to draw the girl's face and brush powdered blush on her cheeks, if desired.

For the hair, wrap yarn around a 9″ piece of cardboard 12 times. Leave the loops intact. Tack the yarn to the middle of the top and the sides of the head, as shown in the photograph.

Gather the 12″ of lace and sew or glue it around the girl's neck. Tie a bow with the ribbon and tack it under her chin.

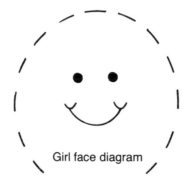

Girl face diagram

Angel Follow the directions for making the girl. To make the rectangular wings, fold the piece of 5″ × 6″ fabric lengthwise, with right sides together. (The folded wing should measure 5″ × 3″.) Stitch across both the short sides and the long edge, leaving an opening to turn the wings right side out. Turn and press. If the fabric doesn't seem stiff enough, you may want to use spray starch when you press it. Gather the rectangle at the center, pull the thread tight, and tack the wings to the base of the head. If you prefer, you could also make heart-shaped wings, as described for the bear.

wings

open

Use the ½ yd. of ribbon to make 3 small bows and tack them to the lace at the bottom of the girl's skirt.

Santa To make the head, follow the directions given for the bunny, omitting the ears. Cut the hat fabric to form a 3¼″ × 6¼″ rectangle. With right sides together, fold, then stitch the 3¼″ edge. On the inside, gather one raw edge with thread, pull the thread tightly and secure it with a knot. Turn the hat right side out and fold under ¼″ of the other raw edge to the wrong side. Put the hat on the doll and tack it all around.

Santa face diagram

To make Santa's hair, wrap the thin crochet thread around two fingers about 15 times. Slide off the loops and tie them with a small length of the thread. For the beard, wrap the crochet thread around three fingers about 15 times. Again slide off the loops and tie them. It will take 5 or so sections of beard to fill in Santa's face. Using the hot-glue gun, glue the hair and beard to the face. Apply glue to each loop where it's tied.

Thread the ribbon through the bell and tie the bell just above Santa's knotted hands.

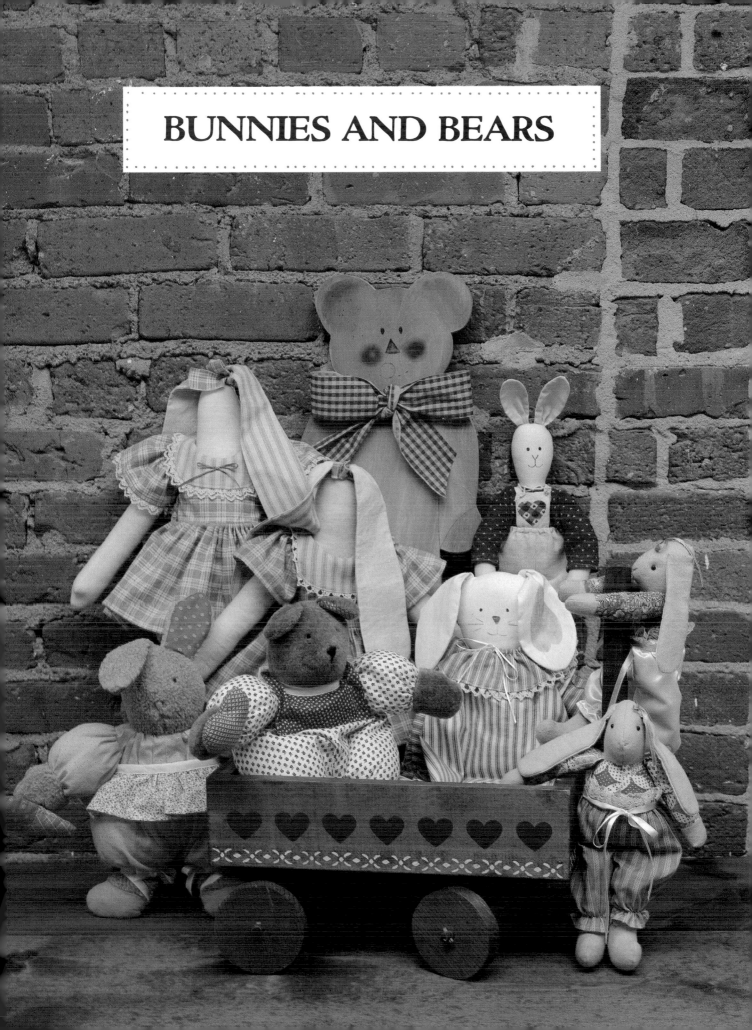

BUNNIES AND BEARS

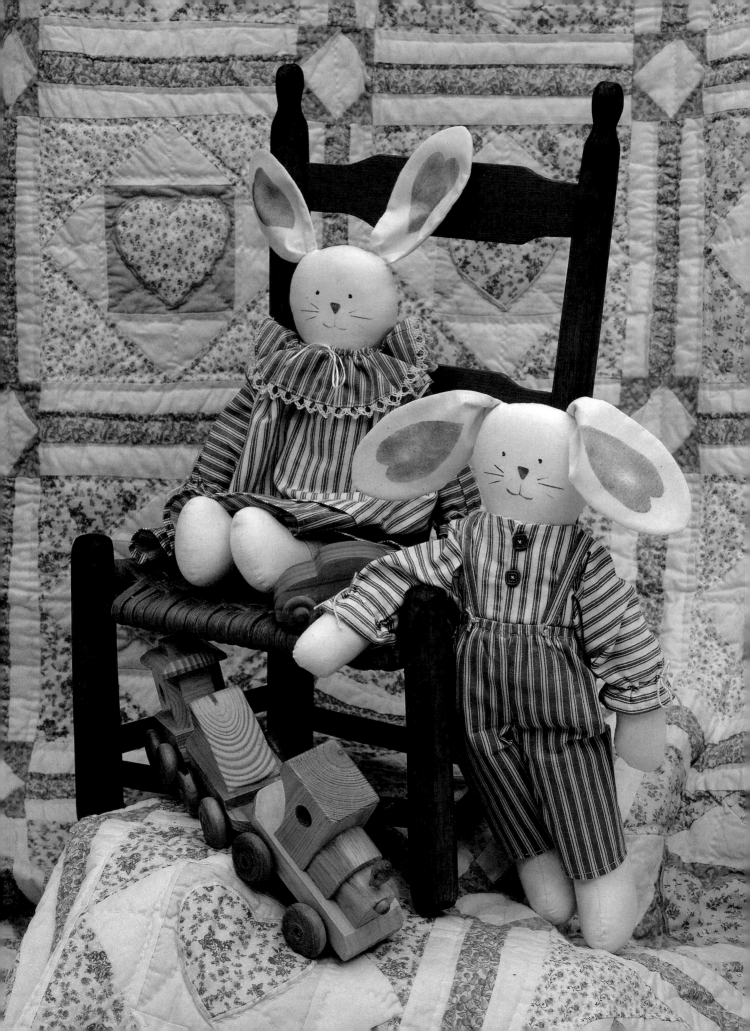

ERIC AND EMMA

Hop along, Peter—here come Eric and Emma. This winsome couple is sure to gain a spot in the heart of anyone near and dear, young or old. Eric and Emma are each about 17″ tall.

Supplies for both dolls

¾ yd. of cotton fabric *or* muslin for the bodies

polyester fiber stuffing

matching thread

Mylar® for stencil

rose and brown acrylic paint

powdered blush for cheeks, if desired

Emma's dress ½ yd. of cotton fabric for dress

⅜ yd. of cotton fabric for pinafore

1 yd. of narrow lace for ruffle (optional)

1 yd. of ⅛″ ribbon

carpet thread

matching thread

Emma's pantaloons ⅜ yd. of cotton fabric

9″ of ⅛″ elastic

matching thread

Eric's shirt ¼ yd. of cotton fabric for shirt

2 small buttons (optional)

carpet thread

matching thread

Eric's pants ⅜ yd. of cotton fabric for pants

9″ of ⅛″ elastic

matching thread

To make each doll Cut 2 body pieces on the fold, 4 leg pieces, and 4 ear pieces. Stitch the ears with right sides together, trim the edges, turn them right side out and press. Using the stencil pattern, cut stencils on the Mylar®. Stencil

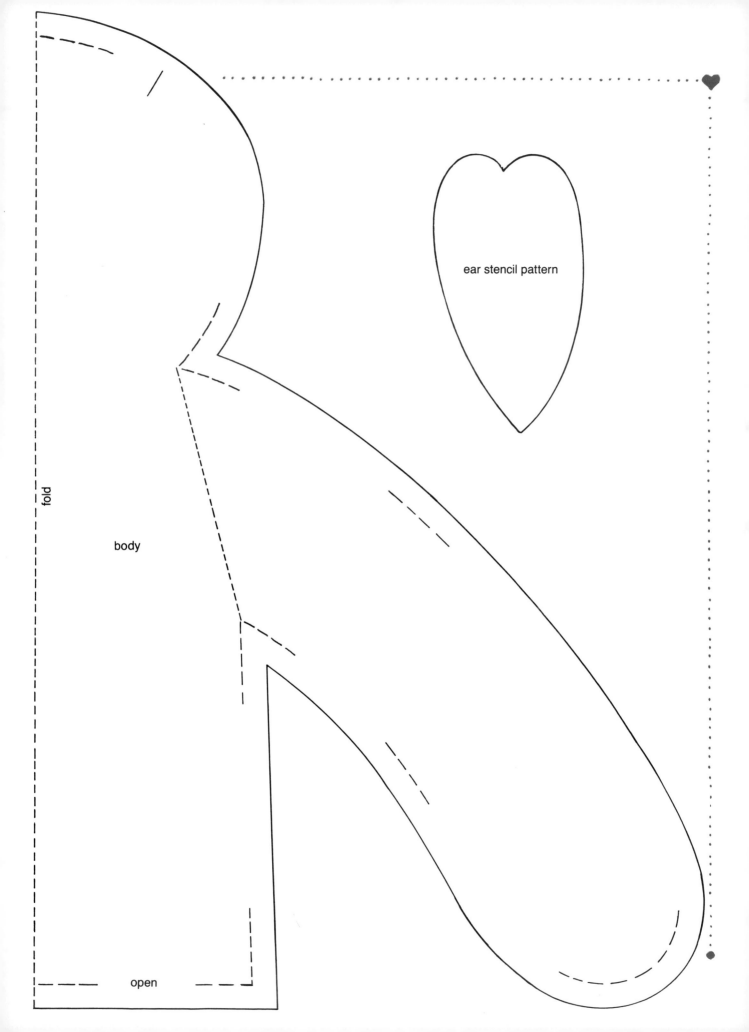

ear stencil pattern

fold

body

open

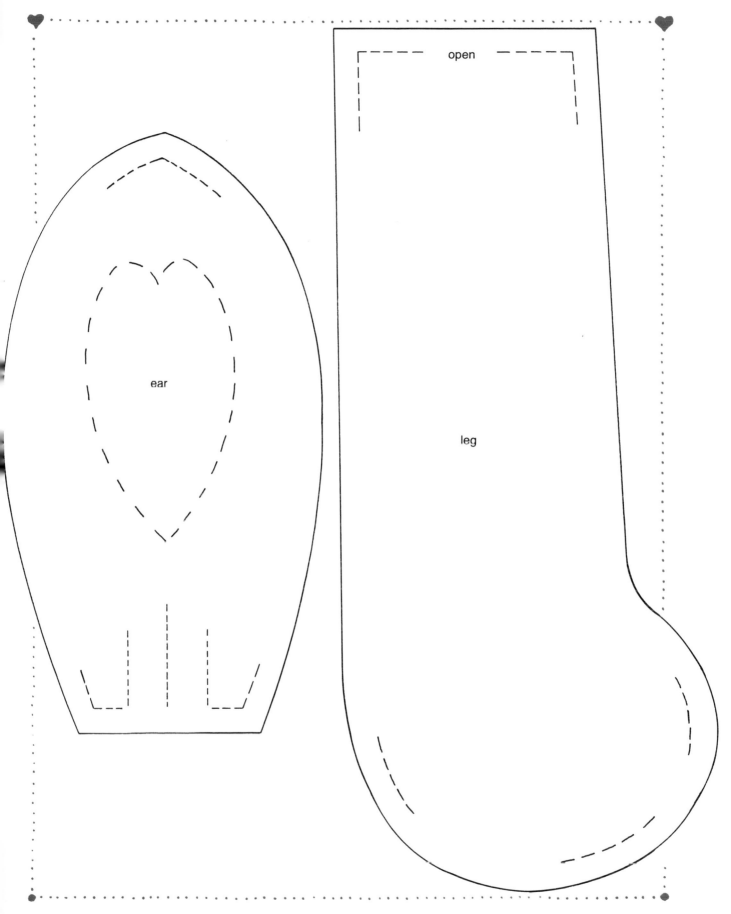

ear

open

leg

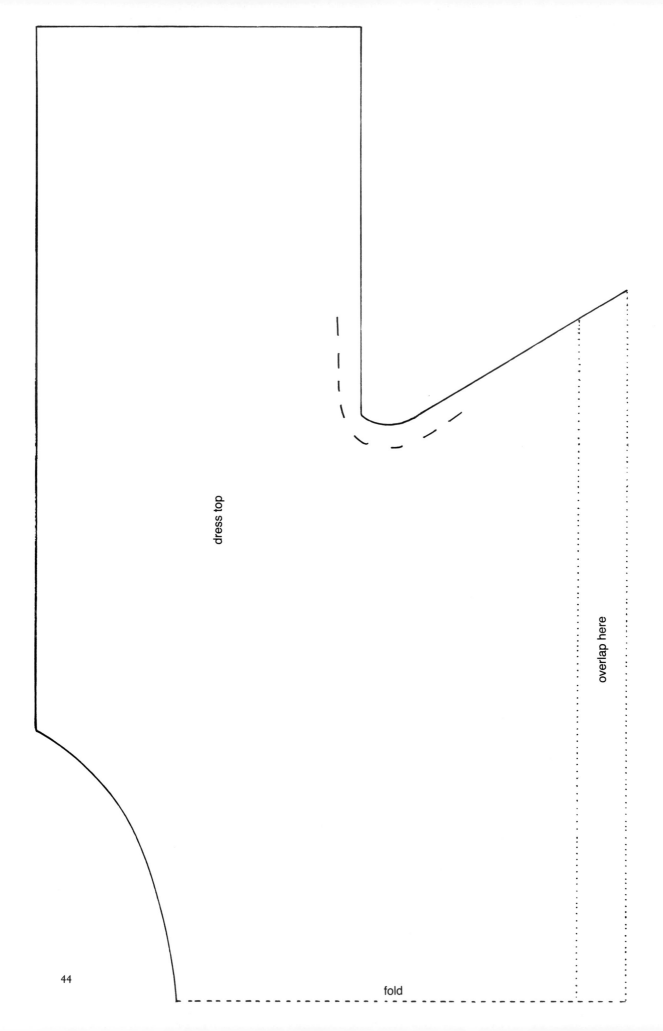

dress top

overlap here

44

fold

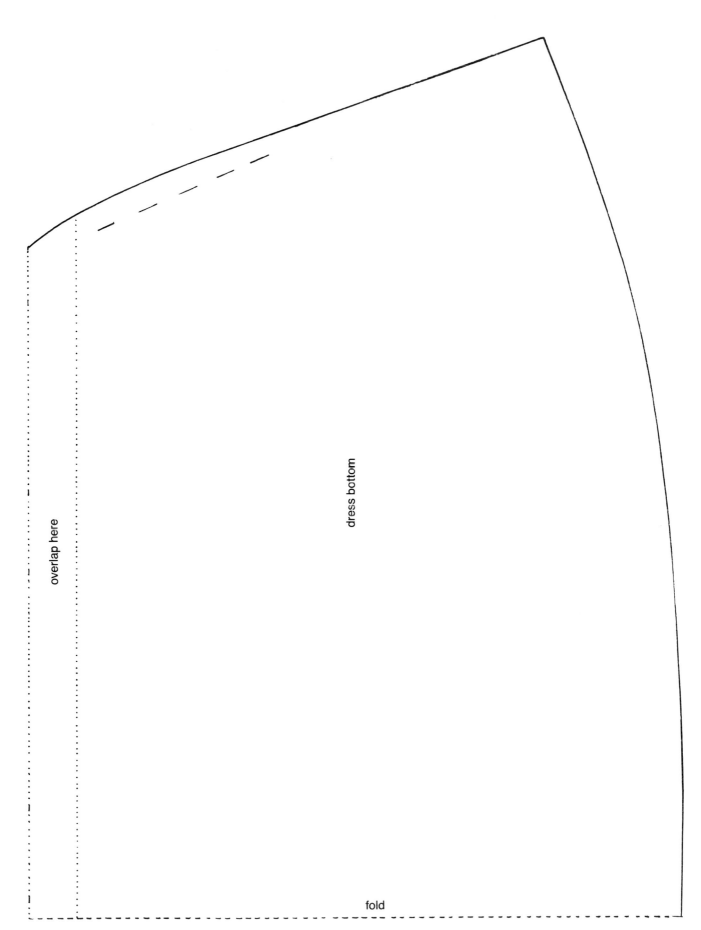

overlap here

dress bottom

fold

45

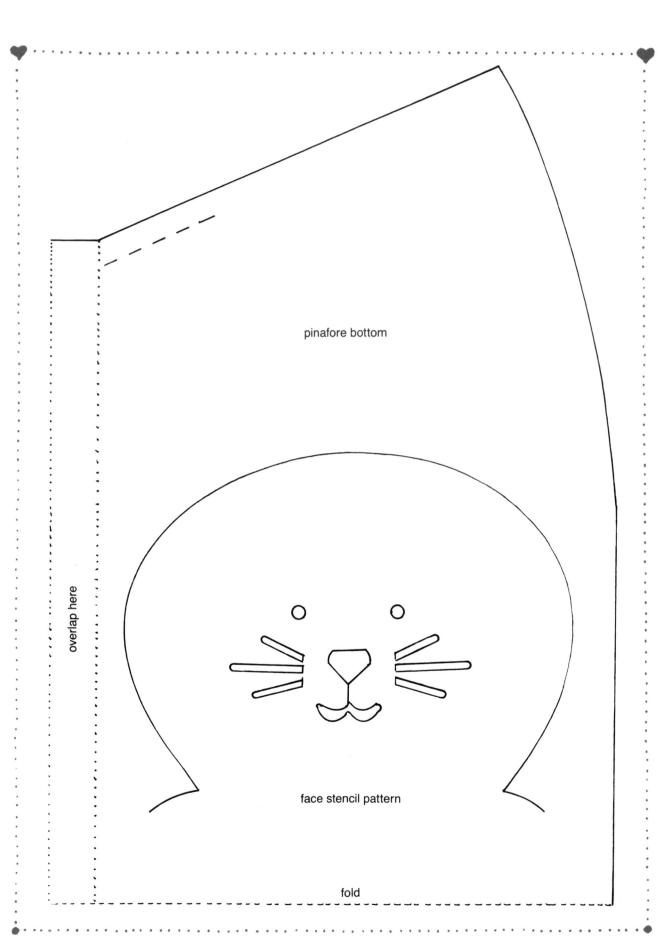

pinafore bottom

overlap here

face stencil pattern

fold

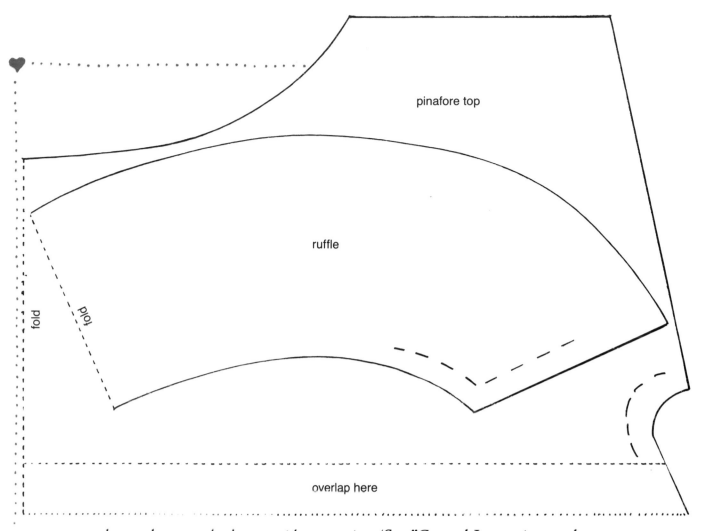

pinafore top

ruffle

fold

fold

overlap here

the ear heart on both ears with rose paint. (See "General Instructions and Tips" for stenciling guidelines.) Let the paint dry thoroughly, then press the ears on the reverse side. Fold the ears on the small dotted lines shown on the pattern, then bring the folds together to the center of the ear. Baste ¼" from the bottom to hold the ears in place.

Stitch the body pieces with right sides together and the ears inserted where indicated on the pattern. Trim the edges and turn right side out. Stencil the face using rose paint for the nose and brown paint for the remaining features. Brush a small amount of powdered blush on the cheeks, if desired.

Stuff the arms to within ½" of the shoulders. Stitch the shoulders where indicated on the pattern. Stuff the head and body firmly. Fold under the bottom edges ¼" and whipstitch the opening closed. With right sides together, stitch along the leg lines, trim the edges, turn right side out and stuff firmly. Fold under the top edges of the legs ¼", whipstitch the opening closed, and sew the legs to the bottom of the body.

Emma's dress Cut out all dress pieces: 2 dress pieces on the fold, overlapping the pattern halves where indicated; 2 ruffle pieces on the fold; and 2 pinafore

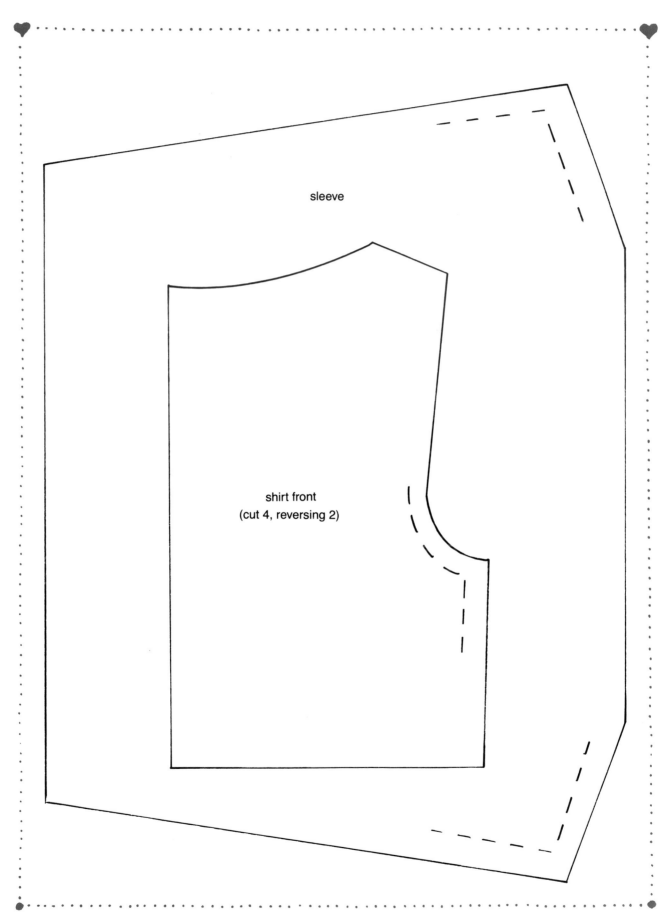

sleeve

shirt front
(cut 4, reversing 2)

pieces on the fold, overlapping the patterns where indicated. With right sides together, stitch the shoulder seams of the dress from the neck edge to the sleeve edge. Press open the seams. Narrowly hem the sleeve edges. Stitch the side seams from the sleeve edges to the bottom of the dress. Clip the curves and turn right side out. Narrowly hem the bottom of the dress. Set the dress aside.

With right sides together, stitch the pinafore shoulder seams. Press open the seams. Narrowly hem the armhole openings. Stitch the side seams from the armholes to the bottom. Turn the pinafore right side out and narrowly hem the bottom edge. Press. Put the pinafore over the dress, pulling the sleeves through the armholes and matching the neck edges together. (The wrong side of the pinafore will be on the right side of the dress.) Baste together the neck edges.

Stitch together the front and back pieces of the ruffle. Sew lace on the edge of the ruffle, if desired. Put the ruffle inside the dress neck edge with the right side of the ruffle against the wrong side of the dress. (Match the side seams.) Stitch a $\frac{1}{4}''$ seam through all 3 layers (pinafore, dress, and ruffle). Clip the curves. Bring the ruffle to the outside of the neck edge. Topstitch $\frac{1}{4}''$ from the neck edge to make a casing. Using a blunt needle, insert ribbon through the casing, entering and exiting in the center front.

Using carpet thread, run a gathering thread through the sleeve about $1''$ up from the hemmed edge of the sleeve. Put the dress on Emma and tighten the neck edge and sleeves. Tie bows at the neck and wrists.

Emma's pantaloons Cut out 2 pantaloon pieces. Narrowly hem each leg. Fold each piece lengthwise, wrong side out, aligning the inseam edges, and stitch the inseam. Turn one leg right side out, insert it into the other leg, aligning the raw edges and matching the inseams. Stitch the crotch from waist to waist across the inseam. Turn the pantaloons right side out. Fold down the waist edge $\frac{1}{8}''$ and press, then fold down $\frac{3}{8}''$ and stitch, leaving a small opening at the back. Insert $9''$ of elastic and secure it at the back. Put the pantaloons on Emma.

Eric's shirt Cut out 2 shirt back pieces, 4 shirt front pieces, and 2 sleeve pieces. Stitch the shirt front pieces to the shirt back pieces at the shoulders, with right sides together. (One set will be the lining.) Press open the shoulder seams. Place the shirt and lining right sides together and stitch from the bottom of one front edge up to the neck, around the neck edge, and down the other front edge. Clip the curves, turn right side out, and press well.

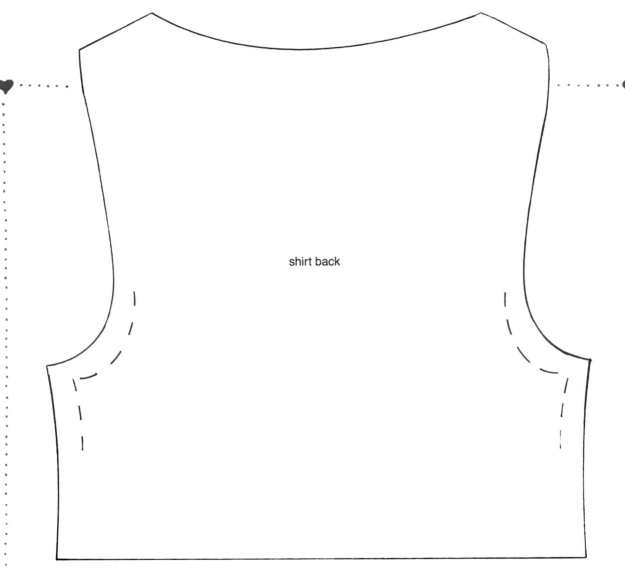

shirt back

Narrowly hem the shirt sleeves and then sew them into the armholes, gathering as necessary to fit. Stitch the sleeve underarms and continue down the side seams. Narrowly hem the shirt bottom.

Using carpet thread, run gathering thread around the sleeves about 1″ up from the hemmed sleeve edges. Put the shirt on Eric, tack it closed in front, and tie or sew 2 buttons on the front.

Eric's pants Cut out 2 pants pieces, 2 strap pieces, and 1 pocket piece. Fold the top of the pocket down ¼″ and stitch. Fold the other 3 sides under ¼″ and press well. Place the pocket on the left front of the pants, as indicated on the pattern (optional). Topstitch around the sides and bottom. Narrowly hem each pant leg. Continue as for Emma's pantaloons, then make the straps.

Fold the strap pieces lengthwise down the center and press. Fold the raw edges to the inside, press them, and topstitch. Tack the straps inside the front waist edge of the pants. Put the pants on Eric, cross the straps in the back, and tack the straps inside the back waist edge. For handkerchief, cut a small square of any fabric desired, fray the edges, fold it and put it in the pocket.

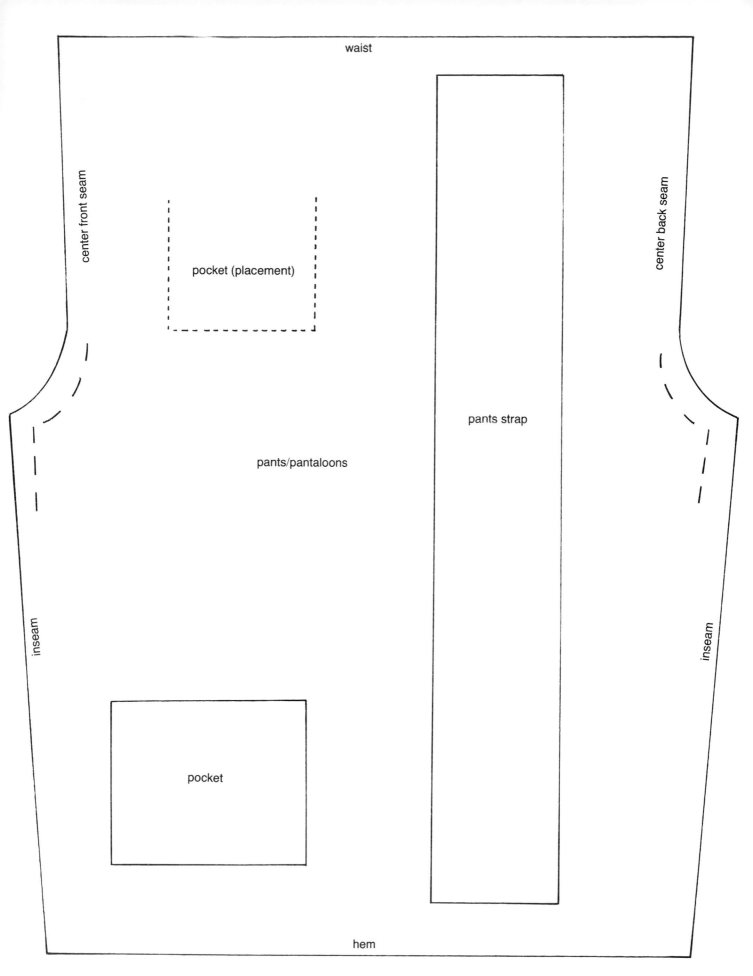

waist

center front seam

center back seam

pocket (placement)

pants strap

pants/pantaloons

inseam

inseam

pocket

hem

51

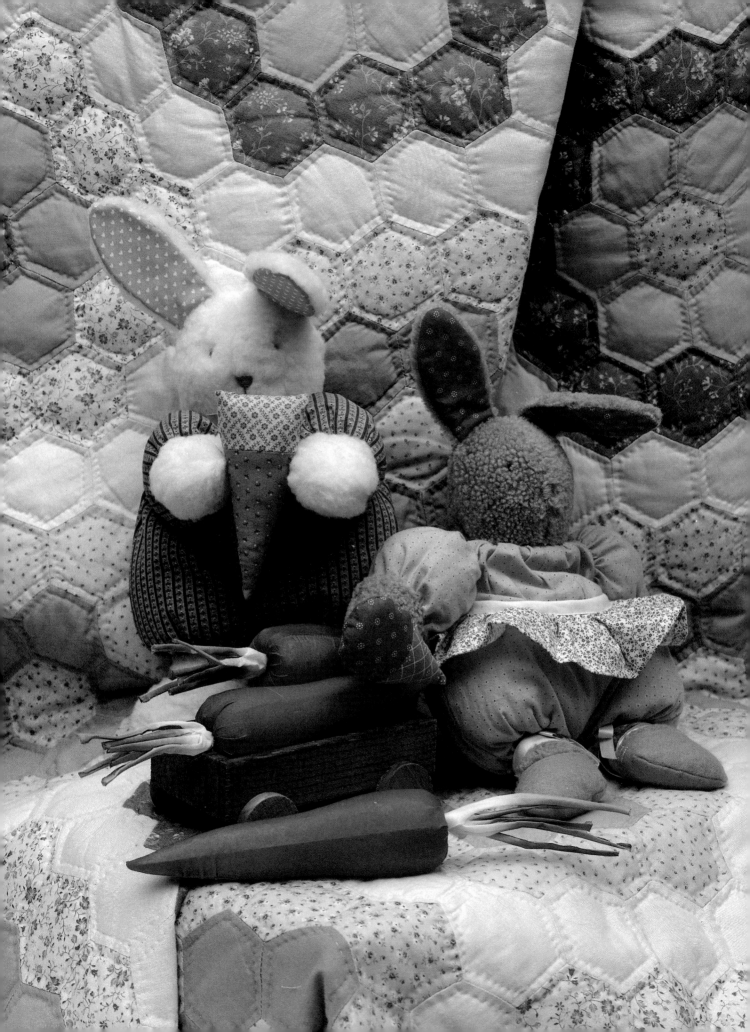

HARE-IETT AND BALLERINA BUNNY

Here's a couple of real cuddle bunnies—furry, soft, and squeezable. You can tell what keeps them in such huggable form: Hare-iett nibbles daintily on her carrot while Ballerina Bunny opts for an ice cream cone. Hare-iett and her friend are approximately 15″ tall, and almost as much around!

Supplies for each bunny

¼ yd. of 45″ sherpa fake fur for faces, ears, hands, and feet

¼ yd. of cotton print fabric for suit

5″ × 6″ piece of cotton print for ears

embroidery floss: black *or* brown for the eyes, peach *or* pink for the nose

polyester fiber stuffing

matching thread

Hare-iett 5″ × 6″ piece of orange print cotton for carrot

3½″ × 5″ piece of green print cotton fabric for stem

¾ yd. of ⅜″ wide ribbon for bow around neck

matching thread

Ballerina Bunny 3″ × 22″ piece of cotton for tutu

¾ yd. bias binding for tutu trim

5″ × 6½″ piece of felt for ballet slippers

1½ yds. of ⅜″ wide matching ribbon for ballet slippers

3″ × 6″ piece of pink print cotton for ice cream

3½″ × 6″ piece of tan print cotton for cone

matching thread

To make each bunny From the sherpa fur, cut 4 head pieces, 4 hand pieces, 2 foot pieces, and 2 ear pieces. Be sure to flip the pattern if you cut one at a time. The fur nap should run down in all pieces except the ears, where it should run up.

Cut out 2 ear lining pieces. Cut out 4 body front-and-back pieces, and 2 sleeve pieces.

With right sides together, stitch the center front head seam and the center back head seam. Also with right sides together, stitch the ear lining to each ear, turn the ears right side out, and pin them to the front of the head, as indicated on the pattern. Set these pieces aside.

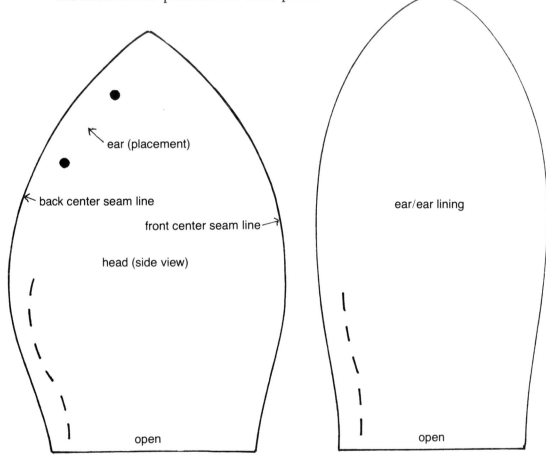

ear (placement)

back center seam line

front center seam line

head (side view)

open

ear/ear lining

open

Stitch the center seams of the front and back suit body pieces, leaving an opening at the back for turning and stuffing. Gather the neck edges of suit body front and back and machine stitch to the head front and back. With right sides together, stitch the shoulder and head seam. Gather the upper and lower sleeve edges.

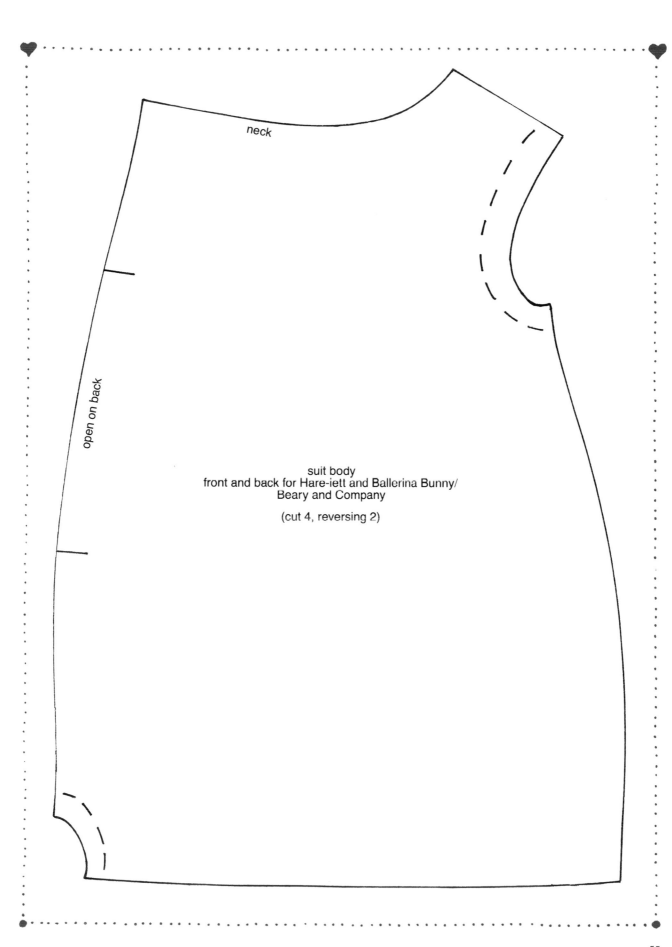

neck

open on back

suit body
front and back for Hare-iett and Ballerina Bunny/
Beary and Company

(cut 4, reversing 2)

sleeve for
Hare-iett and Ballerina Bunny/
Beary and Company

With right sides together, stitch the hand seams up to the thumbs. Open out the hand and stitch it to the sleeve edges. Stitch the sleeve tops to the body. Stitch the completed front suit body piece to the completed back suit body piece at the inner leg seams. Gather the leg edges. With right sides together, stitch the feet to the legs. Also with right sides together, stitch the bunny side seams from the thumb, up the underarms and down the side seams, and around the feet.

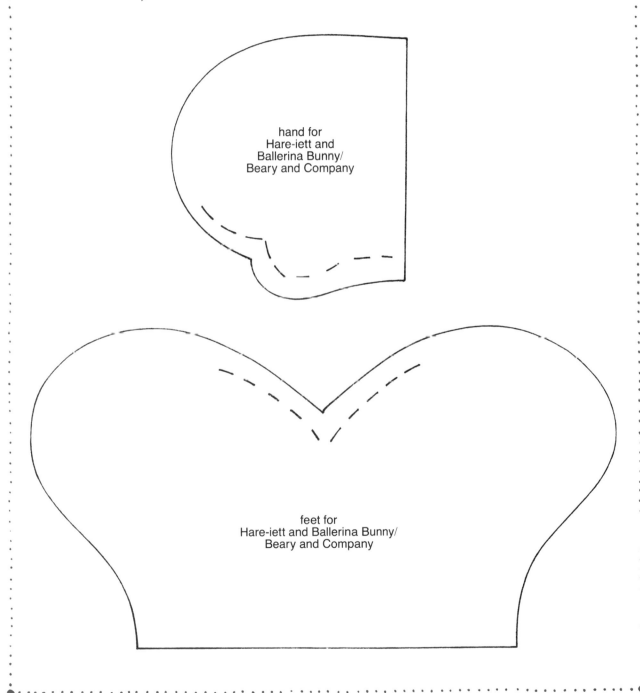

hand for
Hare-iett and
Ballerina Bunny/
Beary and Company

feet for
Hare-iett and Ballerina Bunny/
Beary and Company

Turn the bunny right side out and stuff, pulling the stuffing apart first to fluff it. Firmly stuff the head, hands, and feet and lightly stuff the sleeves and body to give bunny "bounce." Whipstitch the opening closed.

To make the eye, use three strands of embroidery floss and place many small satin stitches one on top of another. Use satin stitches to make the nose.

Once the bunny is complete, you can brush the fur lightly and carefully remove any fur caught in the seams.

Hare-iett's carrot Cut out 2 carrot pieces and 2 carrot stem pieces measuring 2″ × 3″. With right sides together, sew each carrot piece to a stem. Place both carrots right sides together and stitch around the carrot, leaving an opening where indicated on the pattern. Turn right side out, stuff, and whipstitch the carrot closed. Tack the carrot to Hare-iett's hand. Tie a ribbon around her neck.

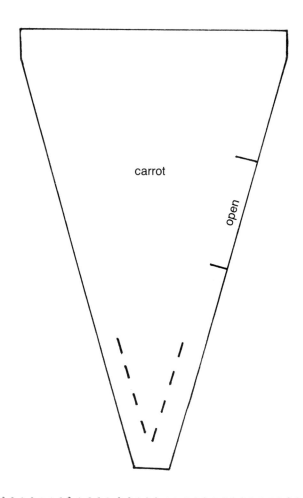

carrot

open

Ballerina Bunny's outfit and ice cream cone Hem the ends and one long edge of the 3″ × 22″ tutu fabric. Gather the remaining long edge to 8″. Center the binding over the gathered edge and edgestitch the entire length of the binding. Tie the tutu on the bunny.

Cut out 2 ballet slipper pieces from felt. Cut the ribbon for the slippers in half. Tack the center of each ribbon to a slipper where indicated on the pattern. Fold the right sides together and, using a ³⁄₁₆″ seam, stitch around the outside edge of each slipper. Turn the slippers right side out and put them on Ballerina Bunny. Bring the ribbons around the legs and tie them in bows.

Cut out 2 ice cream pieces and 2 cone pieces from cotton fabric. Sew each ice cream piece to a cone piece. With right sides together, stitch around the ice cream and cone, leaving an opening for turning. Turn right side out, stuff, and whipstitch the cone closed. Tack the cone to the bunny's hand.

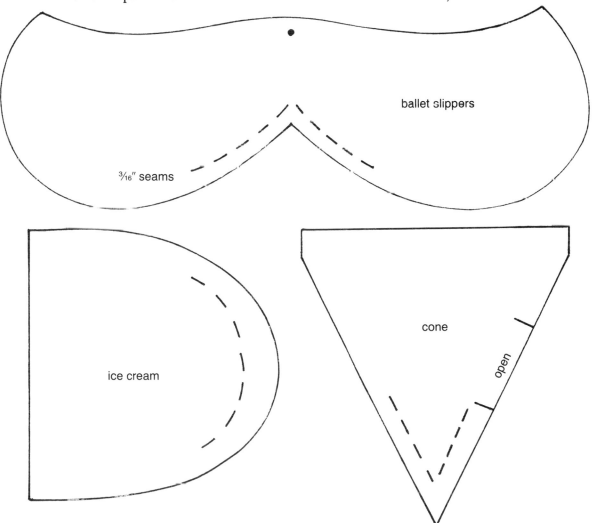

ballet slippers

³⁄₁₆″ seams

ice cream

cone

open

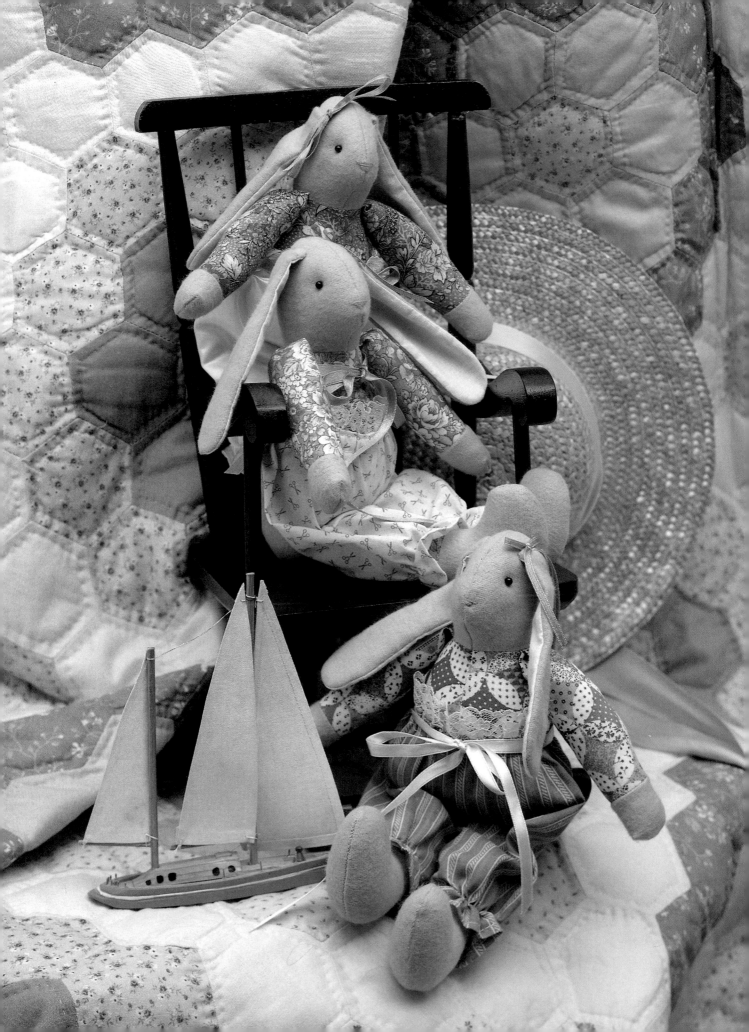

HUNNY BUNNY

This 11″-tall, lop-eared rabbit is so endearing that you can't help picking her up. Her thoughtful expression is magically created with only two beads and a bit of embroidery floss. The children in your life will enjoy dressing and undressing Hunny Bunny—her bloomers are easy for small fingers to manage.

Supplies

♥ 9½″ × 15″ piece of heavy cotton fabric for hands, feet, head, and ears

9½″ × 20″ piece of cotton print fabric for arms, legs, front and back body pieces

5″ × 6″ scrap of fabric for ear lining

8″ × 16″ piece of fabric for bloomers

⅜ yd. of ¾″ lace for waist of bloomers

½ yd. of ⅛″ elastic

¾ yd. of ¼″ ribbon for waist bow

¼ yd. of ⅛″ ribbon for ear bow

pink embroidery floss for the nose

matching thread

polyester fiber stuffing

4mm black beads for eyes

long beading needle (2½″–3″) for eyes

ecru carpet thread for eyes

powdered blush for cheeks, if desired

To make the bunny Cut out 2 body front pieces, 2 body back pieces, 2 head pieces, 4 leg pieces, 4 foot pieces, 2 hand pieces, and 2 ear pieces. Cut 2 ear lining pieces. With right sides together, stitch the ears to the linings, trim the seams, turn right side out, and press. Set the ears aside.

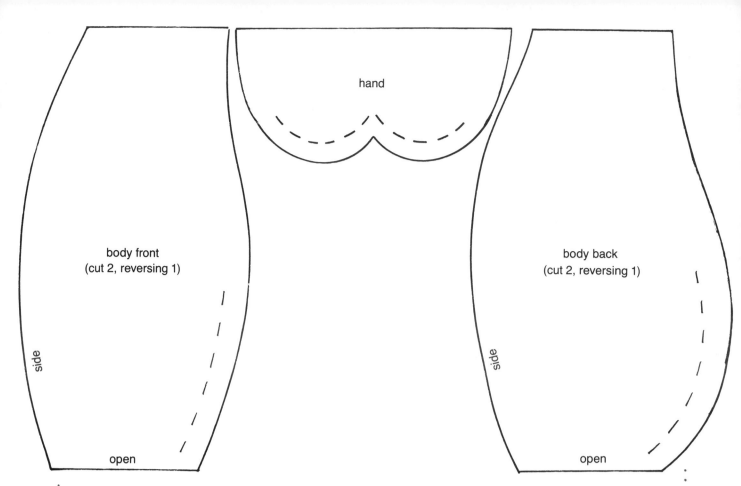

body front
(cut 2, reversing 1)

hand

body back
(cut 2, reversing 1)

side

side

open

open

Stitch together the front and back body pieces at the sides indicated on the patterns. Open up at the seam to turn. With right sides together, stitch 1 hand piece to each lower arm edge. Open up and then fold in half with the right sides together. Stitch from each underarm, all the way around the hand; do not stitch the upper arm edge. Turn the arm right side out and stuff, stopping about ¾″ from the top of the open edge. Baste the upper arm edge closed and gather it slightly. Place the gathered arm on the top of each side seam of the body, with the gathered edge even with the neck edge. The long arm seam should face the back body piece. Baste.

With right sides together, stitch a head piece to the top of each front body front piece, making sure that the noses face the front of the body. With right sides together, pin and then stitch up the body fronts, around the head, and down the body backs. Turn right side out, stuff firmly, and whipstitch the bottom edge closed.

Stitch a foot piece to each leg piece. With right sides together, stitch both legs, turn them right side out, and stuff to within ¾″ of the top edges. Fold the raw edge under ¼″ and attach the leg to the bottom edge of the body.

Fold under ¼″ on each ear and tack by hand flat against the sides of the head. To sew on the 4mm black beads for eyes, thread a long needle with carpet

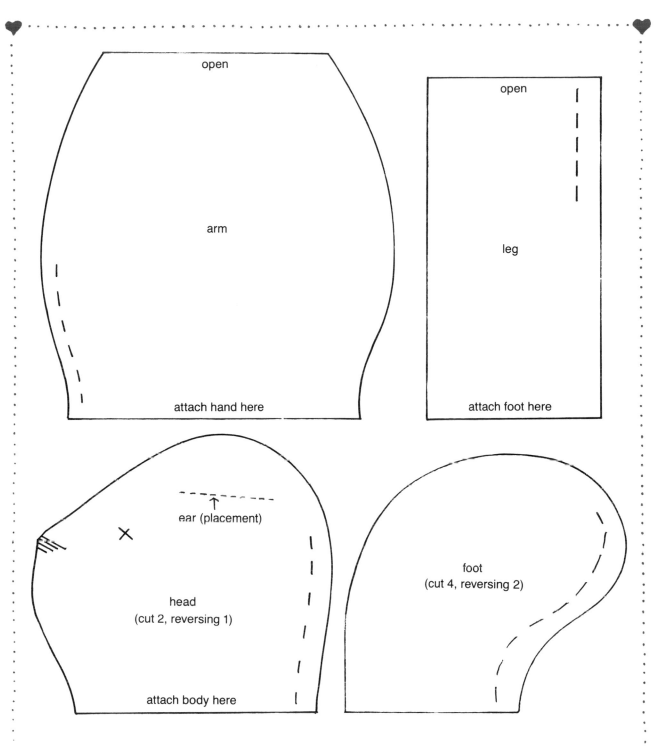

open

arm

attach hand here

open

leg

attach foot here

ear (placement)

head
(cut 2, reversing 1)

attach body here

foot
(cut 4, reversing 2)

thread and knot at the ends. Insert the needle at one eye placement mark indicated on the pattern, pulling the knot just inside the head and bringing the needle back out at the opposite eye placement mark. Place a bead on the needle, insert the needle back into the head underneath the bead, and bring the needle out at the opposite eye placement mark, pulling slightly to indent the bead. Add the second eye bead and indent the fabric as for the

first eye, again emerging from the fabric at the opposite eye. Run the thread back and forth through the head, pulling the needle out underneath the eye beads to conceal the thread. Repeat this "figure 8" motion several times to secure the beads. Snip the thread and tuck it under an eye.

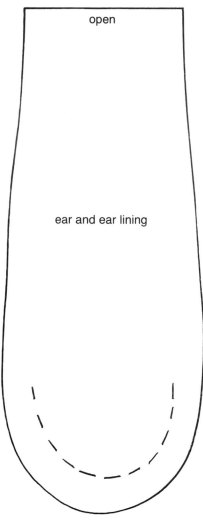

open

ear and ear lining

Using 3 strands of embroidery floss, satin-stitch a small nose where indicated on the pattern. Brush the cheeks with powdered blush, if you desire. Make a bow from the ⅛″ ribbon and tack it to the top of one ear.

Bloomers Cut out 2 bloomers pieces. With right sides together, stitch up the center front seam. Narrowly hem the bottom edges. Open up the bloomers, fold down ⅝″ of the top edge to the inside, and press. Stitch lace to the inside of the top edge, as shown in the photograph. Make another line of stitching ¼″ down from the edge to form a casing. Insert 7″ of elastic and secure the ends. Stitch the back center seam.

On the wrong side of the legs, stitch 3½″ of elastic about ⅝″ up from the hemmed edge, stretching tightly as you sew, to gather. Fold the bloomers, right sides together, aligning the center front with the center back seam. Stitch the leg inseam from hem to hem. Turn the bloomers right side out and put them on the doll. Tie ¼″ ribbon around the waist. You may have to tack the ribbon to the back of the bloomers to keep them in place.

fold line

waist

center front seam

center back seam

bloomers

inseam

inseam

hem

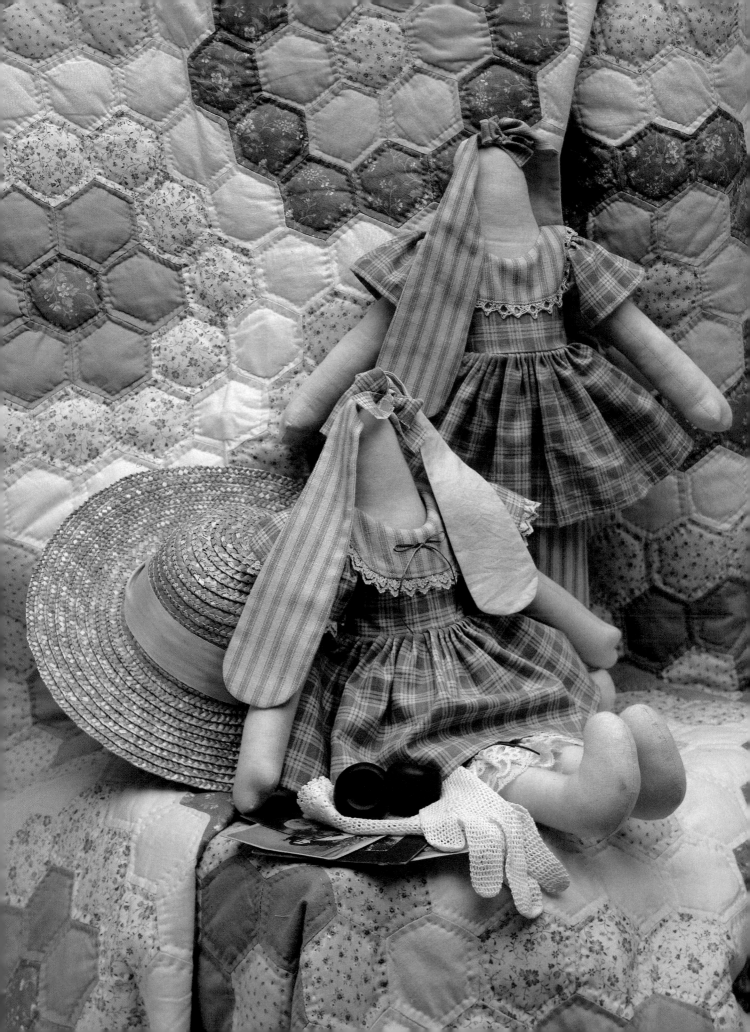

MINERVA

Bedecked in ribbons and homespun bows, Minerva stands approximately 18″ tall. Her ears drape elegantly over her shoulders, demurely framing her featureless face. Featureless dolls date back to Colonial America. To complete the antique look, you may want to stain the muslin in tea (see "General Instructions and Tips") before cutting out the pattern pieces.

Supplies for each doll

♥ ⅜ yd. of cotton fabric *or* muslin for doll body and ears

⅜ yd. of cotton fabric for dress

⅜ yd. of different cotton fabric for collar, bloomers, and ear lining

½ yd. of ½″ flat lace for collar

½ yd. of 2″ gathered lace for bloomer legs

1¼ yds. of ¾″ gathered lace for collar and sleeves

1 yd. of 1/16″ ribbon for bows

¼ yd. of ⅛″ elastic

matching thread

polyester fiber stuffing

To make the doll's body From the muslin, cut out 2 body pieces, 2 arm pieces, 2 leg pieces, and 2 ear pieces. Cut another 2 ear pieces from different fabric.

With right sides together, sew together the ears and linings. Trim the seams, turn right side out, and press. Put the ears right sides together with the edges aligned. Machine or hand baste together across the raw edge. Gather tightly. With right sides together, stitch together the body pieces with the ears inserted at the top of the head where indicated. Leave an opening where indicated.

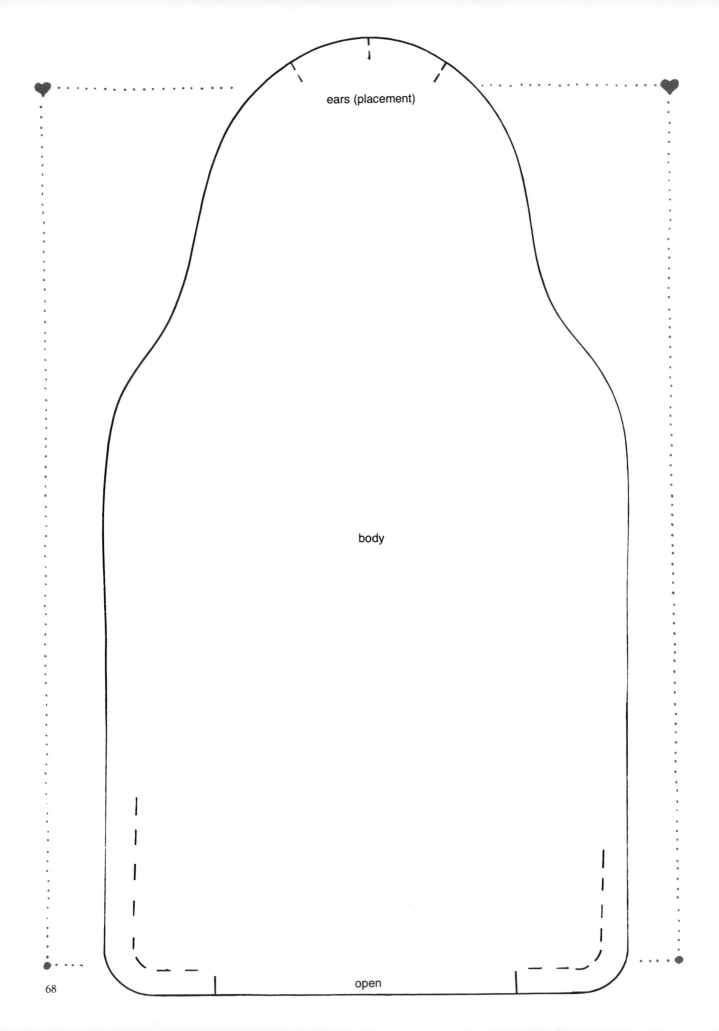

ears (placement)

body

open

68

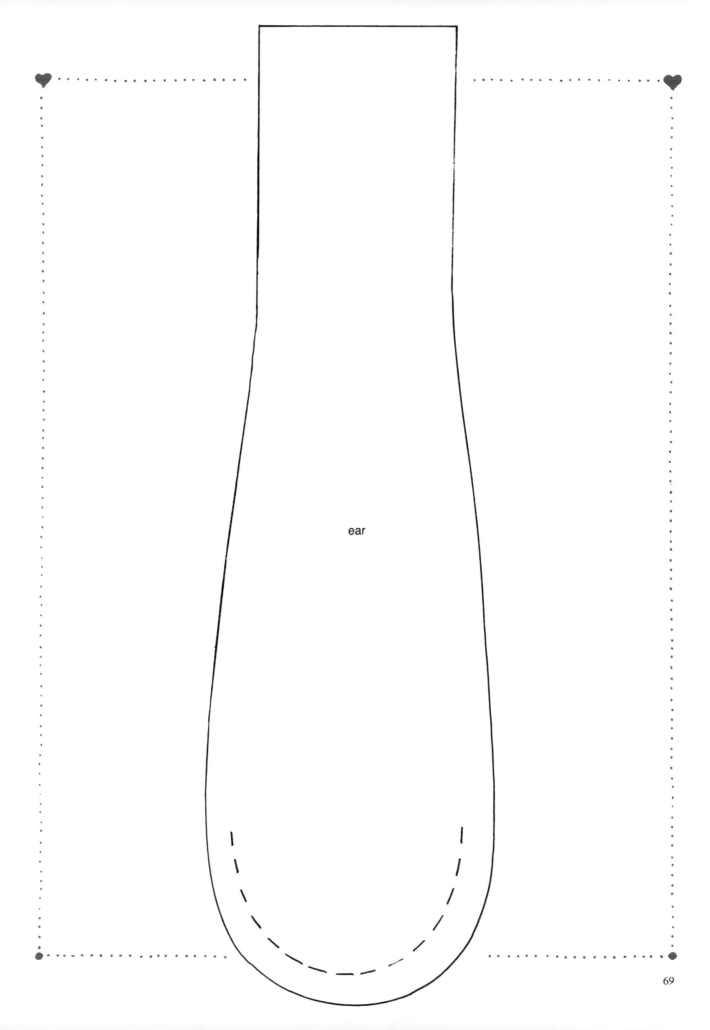

ear

arm

open

Fold the arms and sew them closed with right sides together, leaving openings where indicated. Repeat this procedure for the legs. Turn the arms and legs right side out and stuff them firmly. Fold under ¼" to the inside at the top of each limb and whipstitch the opening closed. Sew the legs to the bottom of the body, and sew the arms to the sides, with the thumbs facing forward.

open

leg

open

71

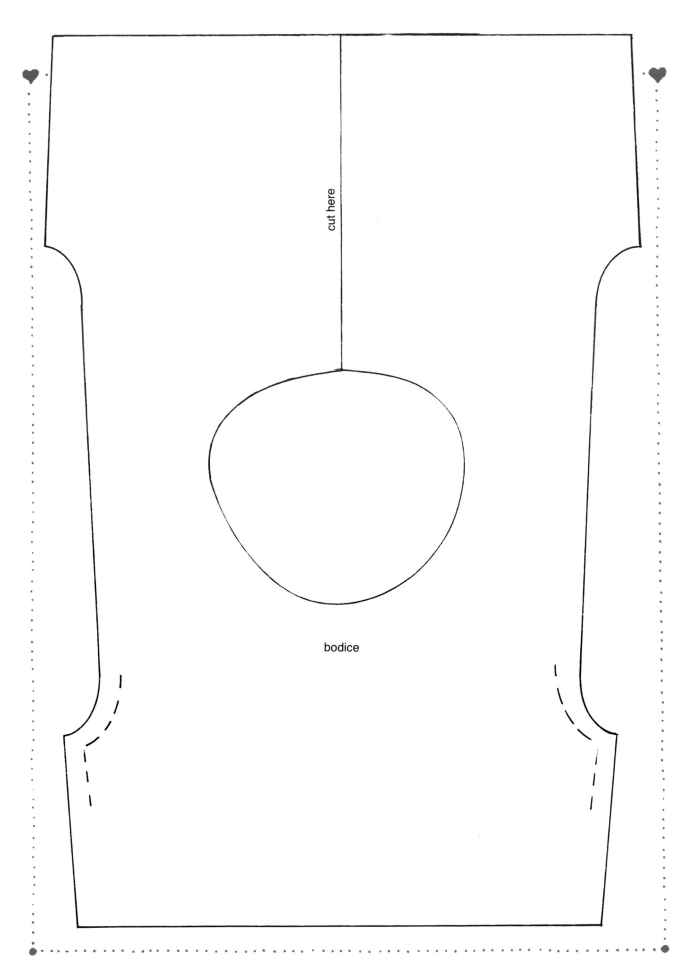

cut here

bodice

Dress From the dress fabric, cut out 2 bodice pieces (one will be the lining), cutting each on the center back line. Also cut 2 sleeve pieces (on the fold), and 1 skirt piece measuring 6″ × 32″. Cut 1 collar from different fabric and cut on the center back line. Turn under ¼″ on each back edge of the collar and stitch. Attach lace to the rounded side of the collar, first basting the flat edge of the lace to the raw edge of the collar (on the right side), then turning the lace out and topstitching close to the edge of the collar. Place the collar on the right side of the bodice, with the collar right side up, and place the lining piece (right side down) on top of both the collar and the bodice. Sew up one side of the back edge, around the neckline, and down the other side of the back. Trim the seams, clip the curves, turn right side out, and press.

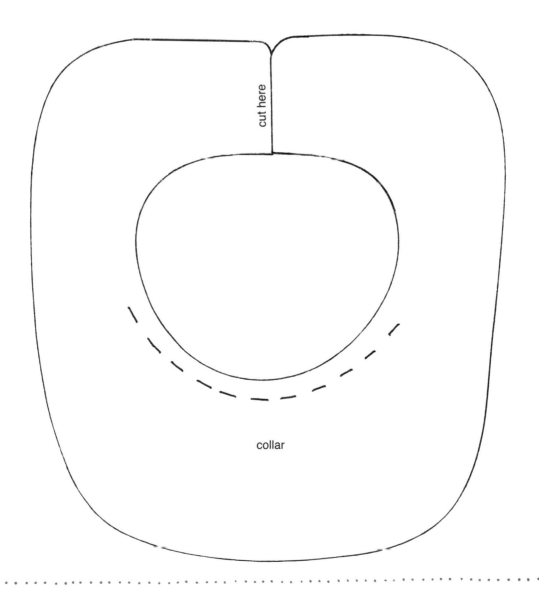

cut here

collar

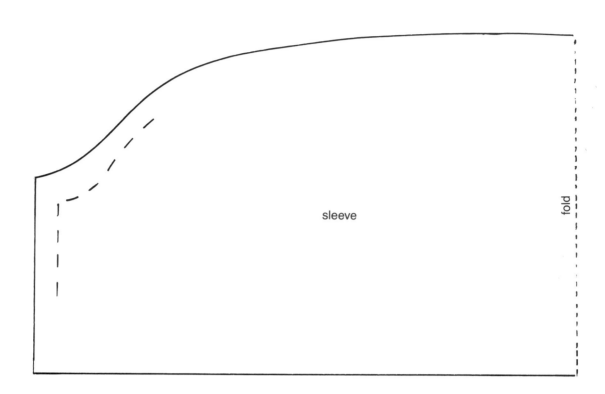

sleeve

fold

Narrowly hem the sleeve edges. Gather the upper edge of the sleeves and, with right sides together, sew the sleeve into the armhole. With right sides together, sew the underarm seam and continue down the side seams of the bodice. Gather the upper edge of the skirt and sew it to the bodice, leaving ¼″ of the skirt extending beyond the center back opening on each side. With right sides together, sew up the back skirt seam to 1″ below the bodice. Turn right side out, narrowly hem the skirt, and put the dress on Minerva. Tack together the back of the dress, hiding the raw edges.

To make a bow for Minerva's head, rip or cut a strip of the dress fabric to measure 1″ × 12″. Fray the edges and tie the strip to one of her ears.

Bloomers From the bloomers fabric, cut 2 bloomers pieces. Stitch the front crotch seam with right sides together. Open out the bloomers at the seam, wrong side up, and fold down ¾″ from the top edge to the inside. Stitch ¼″ from the folded edge, and again ½″ down to form a casing. Insert 8½″ of elastic into the casing and secure the ends. With right sides together, sew the back crotch seam. Narrowly hem the leg edges. With right sides together, sew the inner leg seams. Put the bloomers on Minerva.

For a fancier Minerva, sew wide lace to the bottom edges of the bloomers. After sewing the inseams, run a gathering thread around the leg bottoms. Put the bloomers on the doll, tighten the thread, and secure it. Cut 2 lengths of ribbon, each 14″ long, and tie one around each leg where the lace is sewn to the bloomers. Make a bow from the remaining ribbon and tack it to the collar.

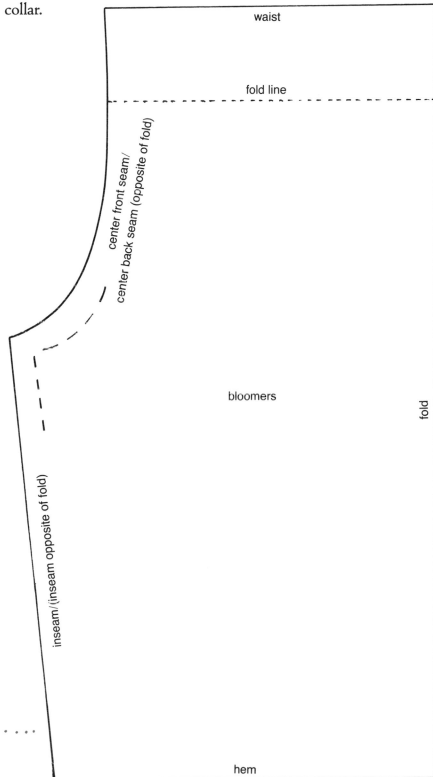

waist

fold line

center front seam/
center back seam (opposite of fold)

bloomers

fold

inseam/(inseam opposite of fold)

hem

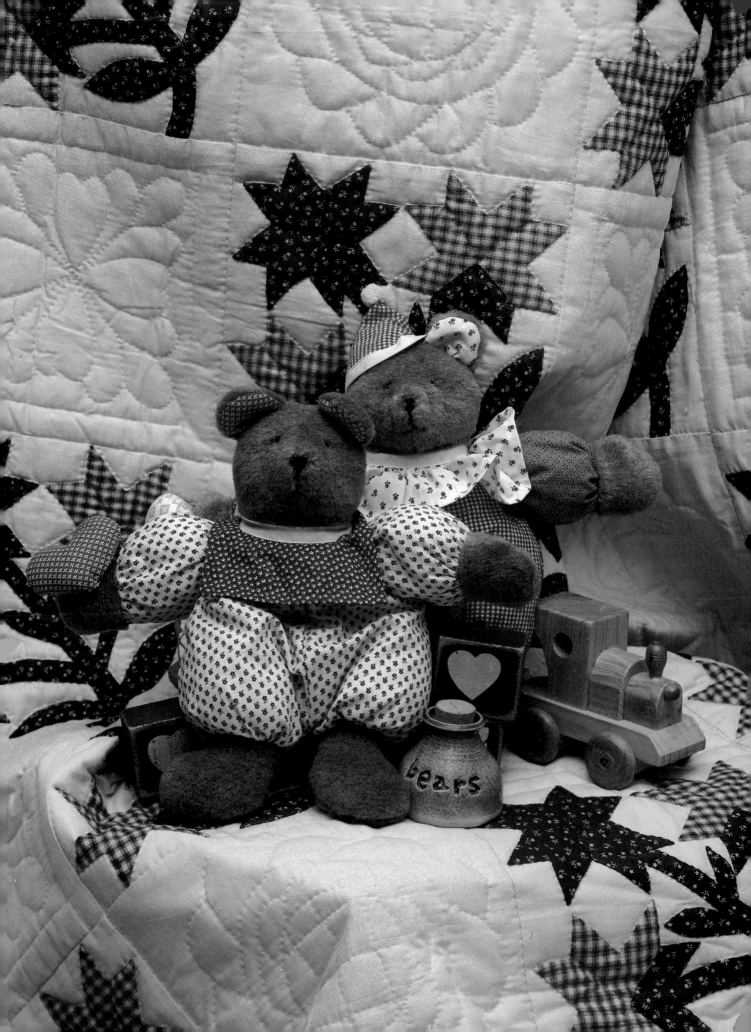

BEARY AND COMPANY

Who can resist these lovable bears? Clown Bear is ready to make you laugh and Beary holds his heart in his hand. Plumped up and huggable, these 13″-tall fellows are loaded with character. They're sure to be center-ring favorites—and will be loved for years to come.

Supplies for each bear

♥ ¼ yd. of short-pile fake fur for bear's head,
 ears, hands, and feet
embroidery floss: choose from black, brown,
 peach, or pink—1 color for all facial features
polyester fiber stuffing
matching thread

Beary ¼ yd. of heart-print cotton fabric
 for suit body
6½″ square of different cotton
 fabric for collar
4″ × 7″ piece of cotton fabric for
 heart and ears
¾ yd. of white double-fold bias
 binding for collar trim
matching thread

Clown Bear 9″ × 19″ piece of print
 cotton fabric for hat and suit
 body

9″ × 15″ piece of different print
 cotton fabric, also for suit body
4″ × 18″ piece of cotton fabric for
 ears and collar
5″ × 7″ piece of cotton fabric for
 balloon
1 yd. of double-fold bias binding
 for collar and hat trim
pom-pom for hat
matching thread
short length of string for balloon

To make each bear From the fake fur, cut 2 head front pieces, 2 head back
 pieces, 4 hand pieces (page 57), 2 foot pieces (page 57), and 2 ear pieces.
 Be sure the nap runs down on all pieces except the ears, where it should run

up. Flip the pattern pieces over if you cut one at a time. For Beary, cut 4 suit body pieces (page 55) and 2 sleeve pieces (page 56) from the heart print. For Clown Bear, cut 2 suit body pieces (page 55) from both of the 2 different prints, and 1 sleeve piece (page 56) from each print. Cut 2 ear pieces from print fabric for either bear.

Stitch the head front pieces together. With right sides still together, bring the seams together at the nose and stitch across the nose, $\frac{1}{4}''$ from the nose tip edge, to give it a flatter appearance. (See Figure 1.) Sew together the head back pieces. With right sides together, stitch the ears to the ear linings, then turn the ears right side out. Pin the ears to the completed head front where indicated on the pattern and set the head aside.

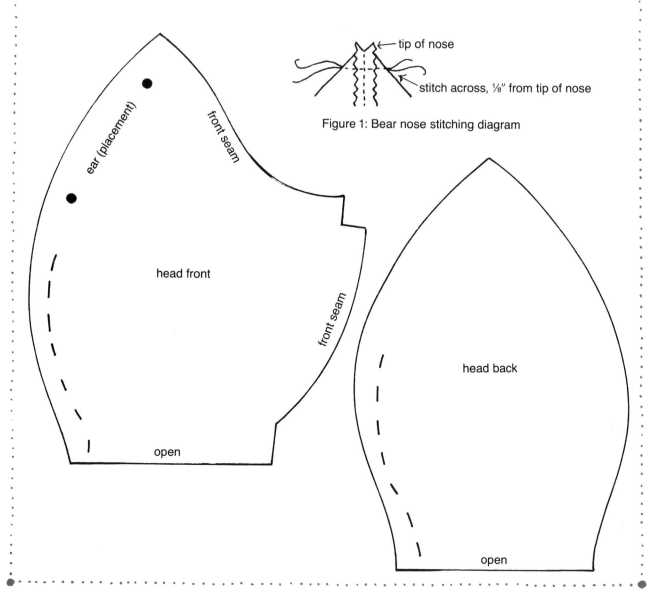

tip of nose

stitch across, ⅛″ from tip of nose

Figure 1: Bear nose stitching diagram

ear (placement)

front seam

front seam

head front

head back

open

open

With right sides together, stitch together the suit body front pieces. Again with right sides together, stitch together the suit body back pieces, leaving an opening to turn right side out. Gather the neck edges to fit, and stitch the neck to the head front and the head back.

With right sides together, stitch the shoulder and head seams. Gather the upper and lower sleeve edges to fit. With right sides together, stitch the hand seams up to the thumbs, as indicated on the pattern. Open out and stitch the hands to the sleeve edges. Stitch the sleeve tops to the body.

Stitch the completed suit front to the completed suit back at the inner leg seams. Gather the leg edges to fit. With right sides together, stitch the feet to the legs. Then, with right sides together, stitch the body from the thumb, down the underarm, along the side seams, and around feet, leaving an opening for stuffing.

Turn right side out and stuff, pulling the stuffing apart to fluff it. Firmly stuff the head, hands, and feet, and lightly stuff the sleeves and body to give the bear "bounce." Close the opening.

Using 3 strands of embroidery floss, satin-stitch the nose. Form the eye by building up many satin stitches, one on top of another. Once a bear has been completed, you can brush his fur lightly and carefully remove any fur caught in the seams.

Beary Cut 2 heart pieces and 1 collar piece. With right sides together, stitch together the 2 heart pieces, leaving an opening where indicated on the

ear

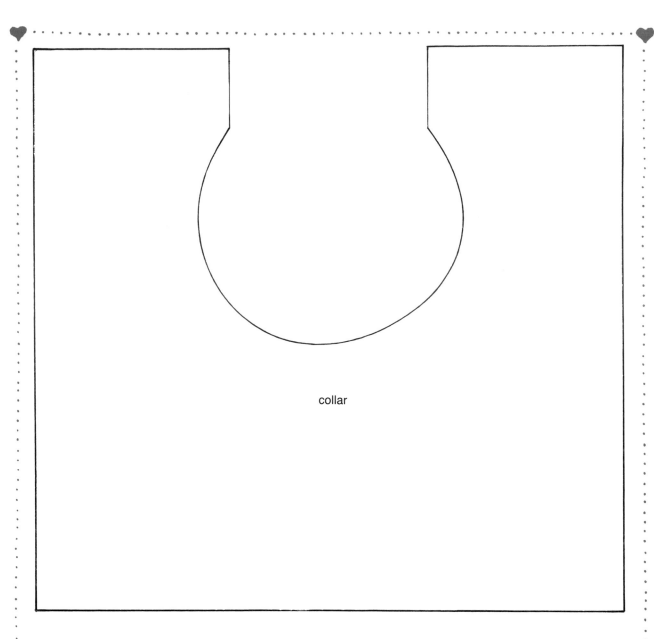

collar

pattern. Turn right side out, stuff, and whipstitch the opening closed. Tack the heart to Beary's hand.

Hem the 3 straight edges of the collar. Center the binding around the neck of the collar and stitch. Edgestitch along the entire length of the binding. Tie the collar around Beary's neck.

Clown Bear Cut 2 balloon pieces, 1 hat, and 1 collar piece measuring $3'' \times 22''$. Overcast the balloon bottoms. With right sides together, stitch together the balloon pieces, leaving the bottom open. Turn right side out and stuff lightly. Tie a string around the bottom to close the balloon, and tack the balloon to Clown Bear's hand.

Hem the 2 short edges and 1 long edge of the collar. Gather the unfinished edge to 6½". Center 26" of neck binding over the collar, and edgestitch along the entire length of the binding. Tie the collar around Clown Bear's neck.

Bind the curved edge of the hat. With right sides together, stitch the hat seam. Turn right side out. Sew the pom-pom to the top and put the hat on Clown Bear's head, tacking it where necessary.

balloon

heart

open

open

hat

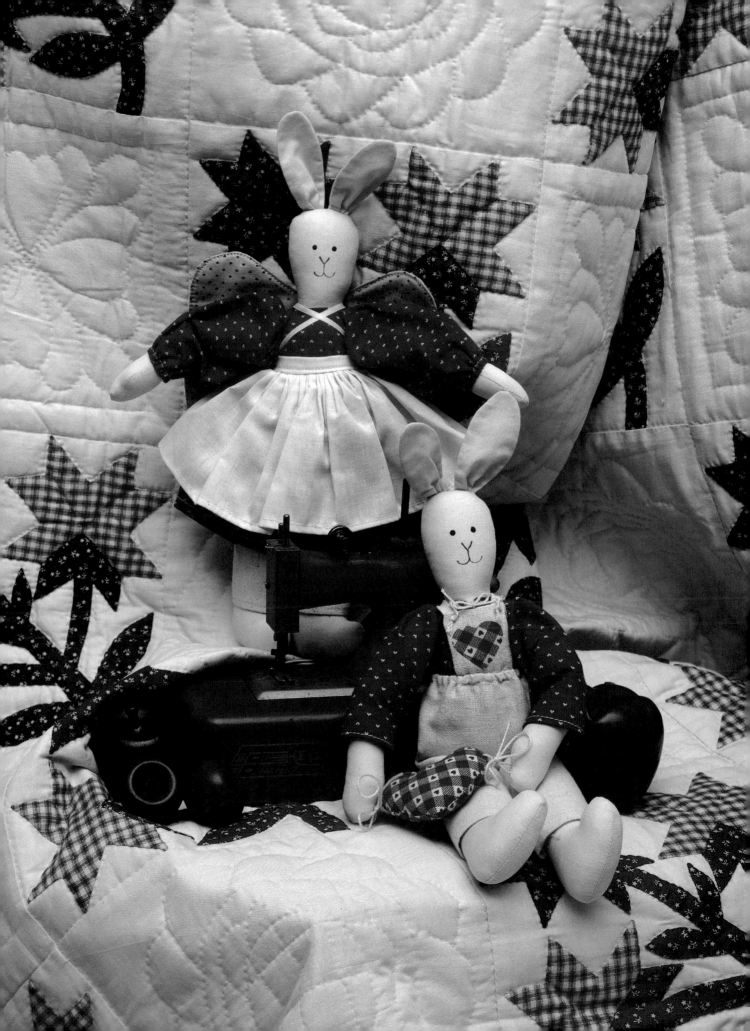

BERNIECE AND BENJAMIN

With their carefree smiles and country clothes, this perky pair will brighten anyone's day. In fact, with them around you might suddenly feel like going fishing or doing a Virginia reel. Berniece and Benjamin are each about 15″ tall, from the tips of their ears to the soles of their bare feet.

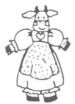

Supplies for the pair

♥ ½ yd. of cotton fabric *or* muslin for bodies

⅜ yd. of cotton fabric for dress and shirt

¼ yd. of cotton fabric for pantaloons and pants

¼ yd. of cotton fabric for apron and wings

scrap of fabric for stuffed heart

matching thread

polyester fiber stuffing

½ yd. of ⅛″ elastic

¾ yd. of ⅛″ ribbon for wings

¼ yd. of fleece for wings

rose and brown acrylic paint *or* dark brown, fine-tip

permanent marking pen for mouth and eyes

powdered blush for cheeks, if desired

To make each doll Cut out 2 body pieces, 4 leg pieces, 4 arm pieces, and 4 ear pieces. With right sides together, stitch the ears, then trim the seams, turn right side out, and press. Gather the bottom edges of the ears to measure about ½″. Baste the ears to the inside of the front head where indicated on the pattern. With right sides together, stitch the body pieces together, leaving an opening at the bottom, where indicated on the pattern. Trim the seams, turn right side out, and stuff firmly. Fold under ¼″ at the bottom edge and whipstitch the opening closed.

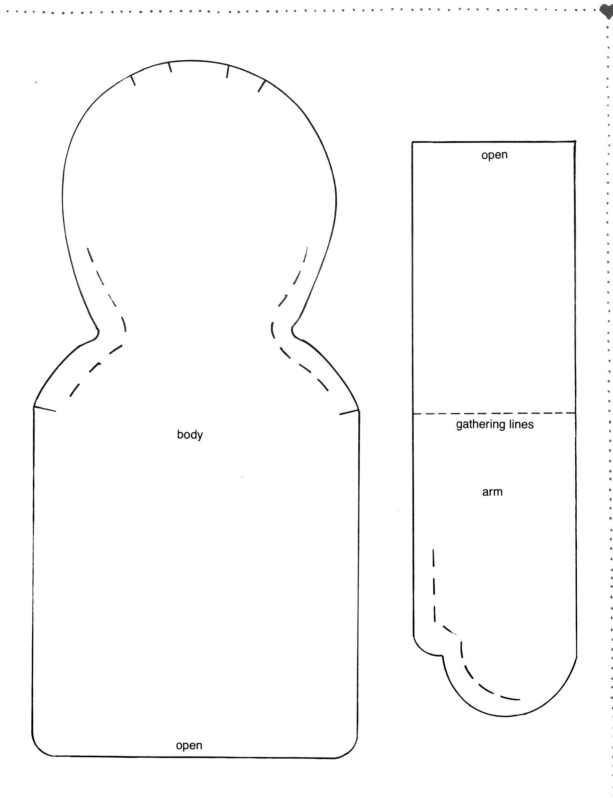

open

body

open

gathering lines

arm

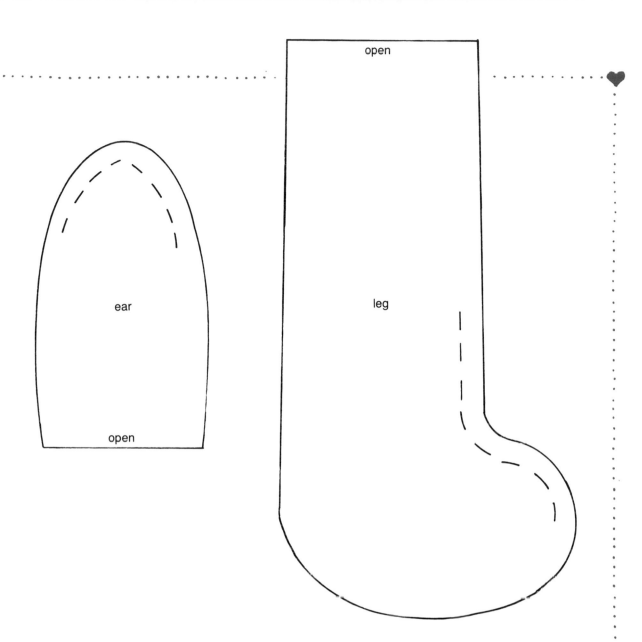

ear

open

open

leg

With right sides together, stitch the arm and leg seams, leaving openings where
 indicated. Trim the seams, turn right side out, and stuff the legs. Fold under
 ¼″ at the top of each leg and whipstitch closed. Sew the legs to the bottom
 of the body. Trim the seams and turn the arms right side out. Stuff the arms
 up to the gathering lines. Run a gathering thread around the arm where
 indicated, pull the threads and tie them. Finish stuffing the arm, fold under
 ¼″ at the top, and whipstitch the opening closed. Sew the arms securely to
 the body where indicated.

Using acrylic paints or a permanent marking pen, if you prefer, follow the diagram
 provided to make the bunny's face. When dry, brush a small amount of
 powdered blush on the cheeks, if desired.

Berniece's dress Cut out 1 dress skirt piece 5¾″ × 18½″, 2 bodice front pieces, 4 bodice back pieces, and 2 sleeve pieces. With right sides together, stitch the bodice front pieces to the bodice back pieces at the shoulders. Press open the seams. One bodice set will be the lining. Place the bodices right sides together, and stitch up one side of the back, around the neck edge, and down the other side of the back. Clip the seams, turn right side out, and press well.

Fold under ¼″ on the sleeve edges. Fold under another ¼″, press, and stitch to make casings. Sew the sleeves into the armholes, gathering where necessary to fit. Insert 2¾″ of elastic into the casings on the sleeve edges. Secure the elastic on either side. Stitch the underarm and side seams.

Gather the skirt to fit the waist of the dress. With right sides together, stitch the skirt to the bodice, with the bodice extending beyond the opening ¼″ on each side. With right sides together, stitch up the back of the dress skirt to the bodice. Narrowly hem the lower edge of the dress. Put the dress on the doll and tack it closed. (Fasteners can also be sewn in to make the dress easier to remove; see "General Instructions and Tips.")

dress sleeves

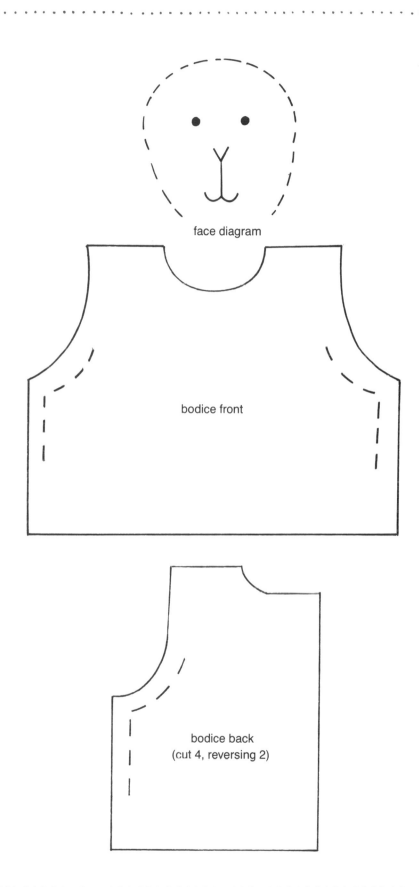

face diagram

bodice front

bodice back
(cut 4, reversing 2)

Berniece's pantaloons Cut out 2 pantaloon pieces. Narrowly hem each leg. Fold each piece lengthwise, wrong side out, aligning the inseam edges, and stitch the inseam. Turn one leg right side out, insert it into the other leg, aligning the raw edges and matching the inseams. Stitch the crotch from waist to waist across the inseam. Turn the pantaloons right side out. Fold down the waist edge ½″ and press, then stitch ¼″ from the folded edge, leaving a small opening at the back to insert elastic. Insert 6″ of elastic and secure it at the back. Put the pantaloons on the doll.

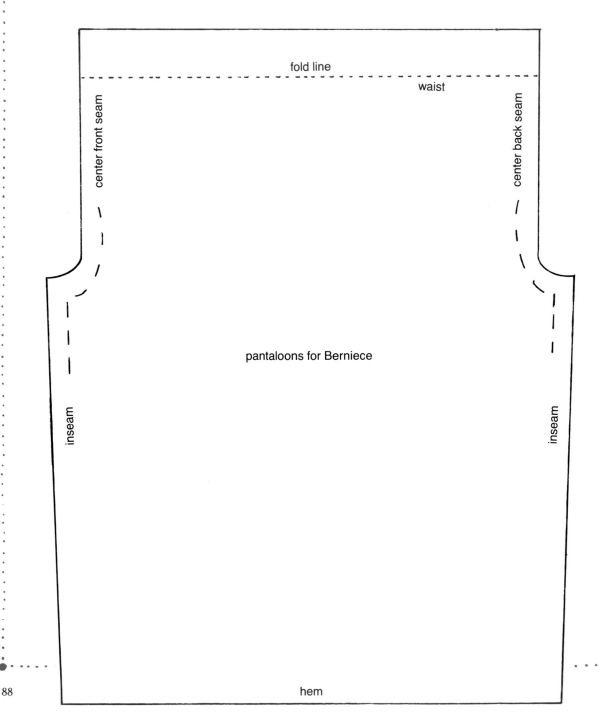

Berniece's apron Cut 1 piece of fabric 5″ × 9″ and another 1″ × 18″. Narrowly hem the 5″ sides and the 9″ bottom of the apron. Gather the top to measure 3″. Fold the long strip in half lengthwise and press. Fold in the raw edges and press. Center the gathered apron edge on the flat apron tie, and fold over and topstitch the length of the tie. Tie the apron on the doll.

Wings Cut 2 pieces out of fabric and 1 piece out of fleece; mark the dots on the

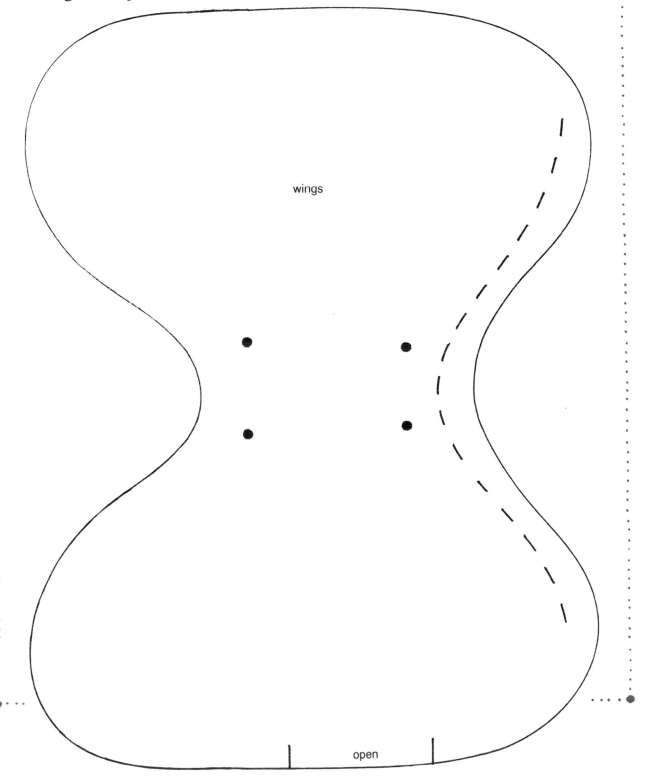

wings

open

pieces. With right sides together and the fleece on the bottom, stitch around the wings, leaving an opening where indicated on the pattern. Trim the seams, turn right side out, and press. Topstitch very close to the finished edge. To tie on the wings, thread a large needle with a length of ribbon. Go from front to back on one of the top dots, then come back to front on the other. Place the doll on the wings and cross the ribbons over on her front. Take the ribbons back to the wings through the dots on the bottom, as indicated on the wing pattern and tie them.

Benjamin's shirt Cut out 2 back pieces, 4 front pieces, and 2 sleeve pieces. Make Benjamin's shirt as you did the bodice of Berniece's dress, with one exception: what was the front of the bodice will be the back of the shirt. His sleeves are narrower than Berniece's, so there's no need to gather the edges. Fold under ¼" at the wrist edges and hem the sleeves; and narrowly hem the shirt bottom. Tack the shirt closed in front. (Fasteners can be used instead, if you prefer; see "General Instructions and Tips.")

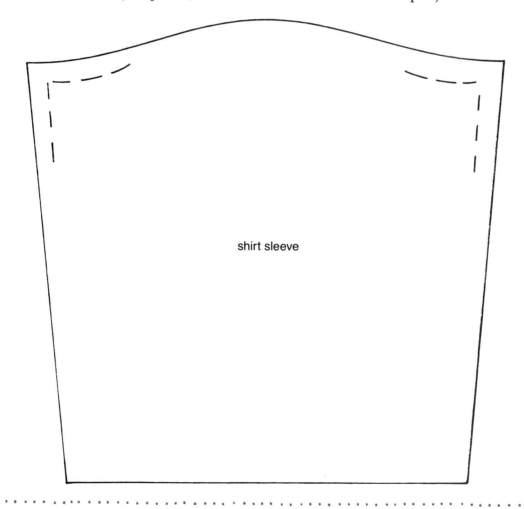

shirt sleeve

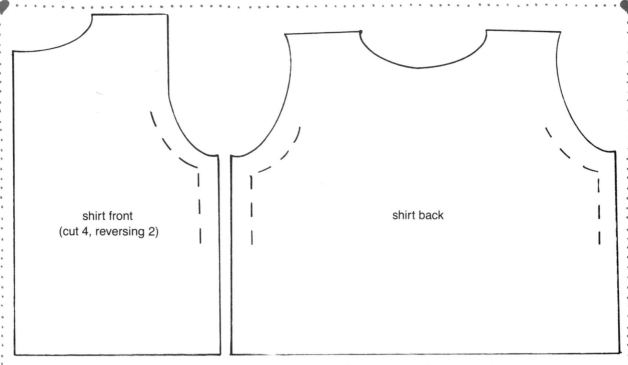

shirt front
(cut 4, reversing 2)

shirt back

Benjamin's pants Cut out 2 pants pieces, 2 bib pieces, and 2 strap pieces.
Narrowly hem the pants legs. Fold each pants piece lengthwise, wrong side
out, aligning the inseam edges, and stitch the inseam. Turn one leg right

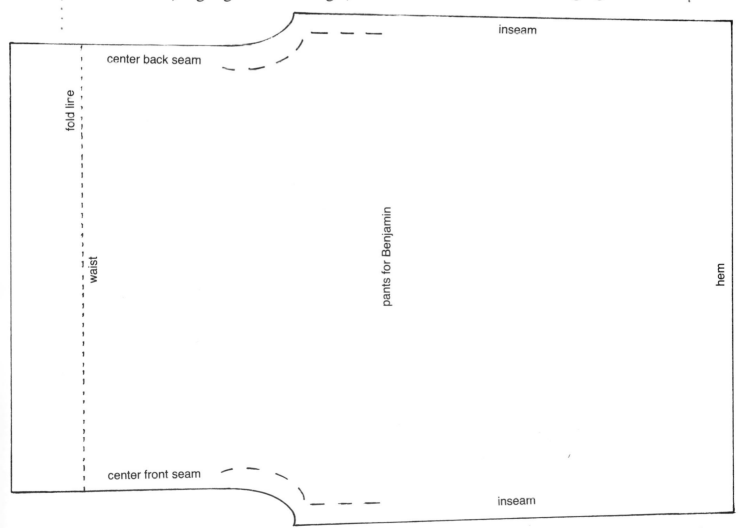

inseam

center back seam

fold line

waist

pants for Benjamin

hem

center front seam

inseam

bib

strap

side out, insert it into the other leg, aligning the raw edges and matching the inseams. Stitch the crotch from waist to waist across the inseam. Turn the pants right side out. Turn down ¼″ at the waist, and then another ½″ and stitch, leaving a small opening at the back to insert elastic. Insert 6″ of elastic and secure at the back. Fold the straps down the center, fold in the raw edges, and press well. Topstitch. Lay the straps between the bib pieces where indicated, and stitch around one side, the top, and the other side of the bib. Trim the corners, turn right side out, and press. Appliqué or stencil a heart on Benjamin's bib at this point, if you wish (see "General Instructions and Tips"). Put the pants on Benjamin, cross the straps in the back, then tack them inside the pants waist.

Stuffed heart If you wish either doll to hold a stuffed heart, cut out 2 heart-shaped pieces from a scrap of fabric. Stitch with right sides together, leaving a small opening. Trim the seam, turn right side out, and stuff. Whipstitch the opening closed and tack the heart to Benjamin's or Berniece's hands.

appliqué heart

heart

open

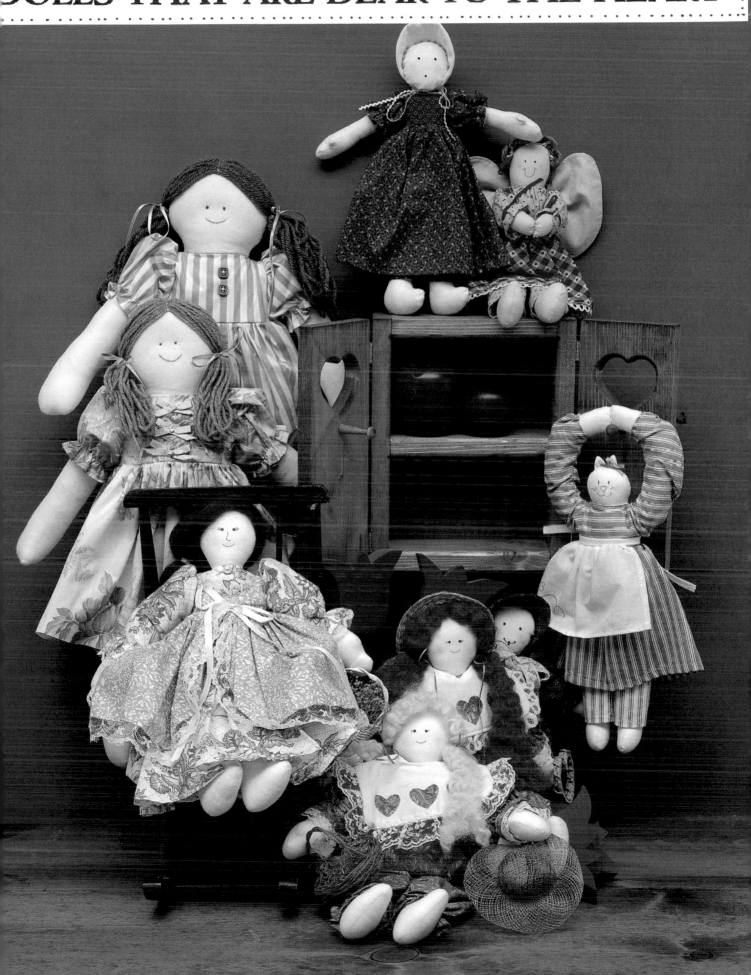

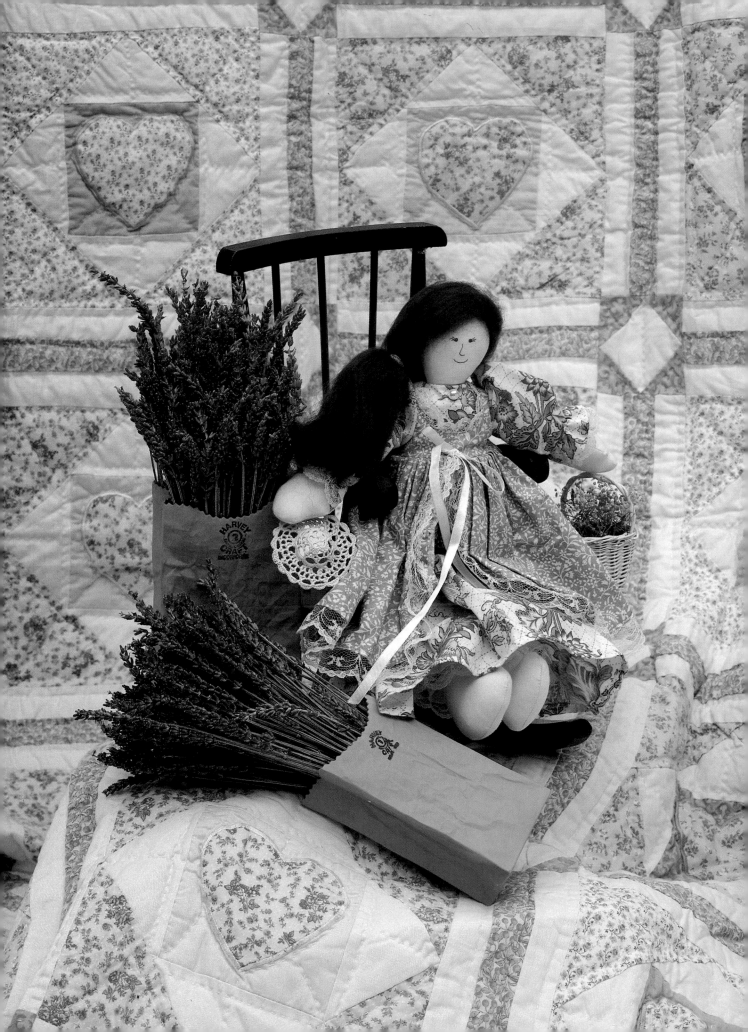

HILLARY

Tall (17″) and elegant, Hillary is every inch a lady. On her dress she wears a lace-edged overskirt (actually sewn onto the dress); underneath she wears lace-edged bloomers. But her fancy clothes can't hinder her high spirits. Hillary would love to play with a young friend of yours.

Supplies

♥ ¼ yd. of cotton fabric *or* muslin for body

polyester fiber stuffing

black, fine-tip permanent marking pen for face

powdered blush for cheeks, if desired

10″ × 18″ piece of cotton fabric for bloomers

1⅛ yd. of ¾″ flat lace for bloomers, sleeves, and bodice trim

½ yd. of cotton fabric for dress

¼ yd. of different cotton fabric for overskirt

1½ yds. of 1¼″ flat lace for overskirt

¾ yd. of ⅛″ elastic

6mm pearl bead *or* small button for bodice

½ yd. of ¼″ ribbon for dress front

1 yd. of ⅛″ ribbon for hair

wool roving *or* mock wool roving for hair

matching thread for body, bloomers, dress, overskirt

small lace *or* straw hat (optional)

basket of flowers (optional)

To make the doll Cut out 2 body pieces (page 134), 4 leg pieces (page 135), and 4 arm pieces (page 135). With right sides together, stitch the body, leaving an opening where indicated. Again with right sides together, sew the legs

and arms, leaving the tops open. Clip the curves, turn all pieces right side out, and stuff firmly. Whipstitch the bottom of the body closed. Stop stuffing about ¾" from the tops of the arms and legs. Turn under ¼" to the inside and sew the limbs closed, then sew them to the body.

Carefully draw the face using the black, thin-line marker. You might want to experiment on a scrap of fabric to get the look you want, or follow the diagram on page 134, and omit the nose. Lightly brush powdered blush on the cheeks, if desired.

Hillary's bloomers Cut out 2 bloomers pieces on the fold. With right sides together, stitch up the center front seam. Open out the bloomers, and fold over the top edge ¾" to the inside. Make a line of stitching ¼" down from the folded edge. Insert 6" of elastic into the casing and secure. Stitch the back center seam. Narrowly hem the leg edges and attach ¾" lace at the inside edge. Stitch elastic to the wrong sides of the legs, about ⅝" up from the hemmed edge, stretching tightly as you sew, to gather. Fold the bloomers, right sides together, aligning the center front with the center back seam. Stitch the leg inseams. Turn the bloomers right side out and put them on the doll.

Hillary's dress Cut 2 bodice front pieces (1 will be the lining), 4 bodice back pieces (2 will be the lining), 2 sleeve pieces, and 1 skirt measuring 9½" × 45". From the overskirt fabric, cut 1 overbodice piece and 2 overskirt pieces measuring 6¼" × 22". Following the cutting guide, cut a curve at each bottom front corner of the overskirt.

Stitch ¾" lace to the right side of the front edge of the overbodice, using a *scant* ¼" seam. Fold the lace up and press. Lay the overbodice piece on one of the

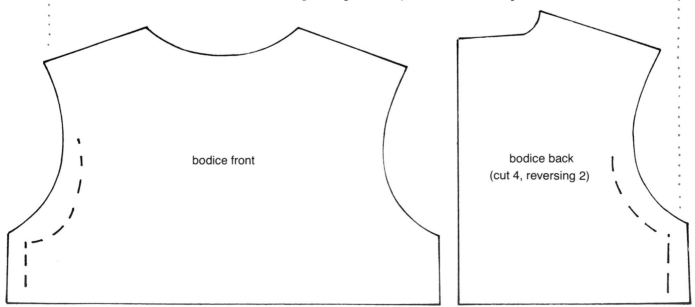

bodice front

bodice back
(cut 4, reversing 2)

fold line

waist

center front seam/
center back seam (opposite of fold)

fold

bloomers

inseam/(inseam opposite of fold)

hem

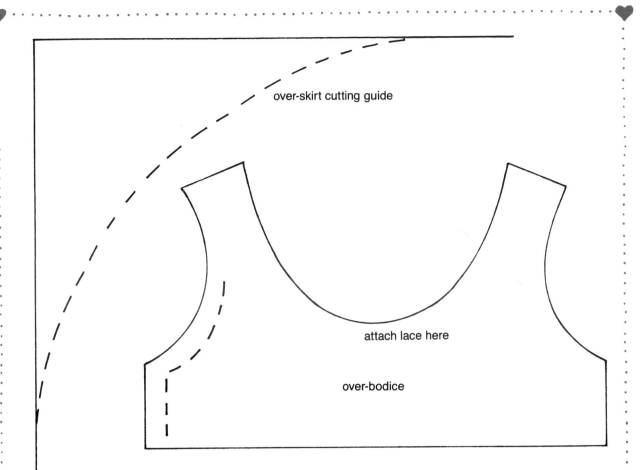

over-skirt cutting guide

attach lace here

over-bodice

bodice fronts and stitch on the curved edge, next to the lace, so that the overbodice, bodice, and lace are now sewn together. Stitch the shoulder seams of the bodice and lining. Lay the lining on top of the dress bodice, and stitch up one back side, around the neck, and down the other back side. Clip the curve, turn right side out, and press. To remove excess bulk, trim away the extra bodice underneath the overbodice to within ¼" of the seam.

With right sides together, stitch the sleeves into the armholes, gathering them at the shoulder. Narrowly hem the sleeve edges and attach lace. Sew a 3¼" piece of elastic to the wrong side of the sleeve, about ⅝" from the hemmed edge, stretching tightly as you sew, to gather. Stitch the underarm seam and the side seam. Clip the seam under the arm.

Fold under ¼" of the bottom and curved edge of the overskirt. Stitch lace to the inside edge, easing it at the curves. Gather the waist of the overskirt to fit the waist of the bodice. With right sides together, pin it on the dress top, matching the lace edges at the center. Let the back edges extend ¼" past the center back opening. Stitch around the waist.

gather

sleeve

Narrowly hem the dress skirt and gather it to fit, then sew it to the dress edge, underneath the overskirt. Your gather won't show under there, so you can take larger tucks. Make a bow from ¼″ ribbon and tack it to the waist of the dress at the center. Sew a small pearl or button to the bodice front. Sew up the back seam of the dress skirt to within 1″ of the waistline, then sew up the back seam of overskirt to within 1″ of the waist. Turn the dress right side out, put it on Hillary, and tack it closed in the back. (If you prefer to use fasteners to secure the dress, see "General Instructions and Tips.")

Hair Cut a 17″ hunk of hair from the wool roving and experiment wrapping it around the doll's head so that it resembles long hair. When you've decided how you want it to look, tack or hot-glue the roving to the doll's head where necessary, leaving the ends to hang at the side. Cut the ⅛″ ribbon into 3 equal strips. Braid the strips and tie them around the ponytail. Tack a hat or basket to Hillary's hand, if desired.

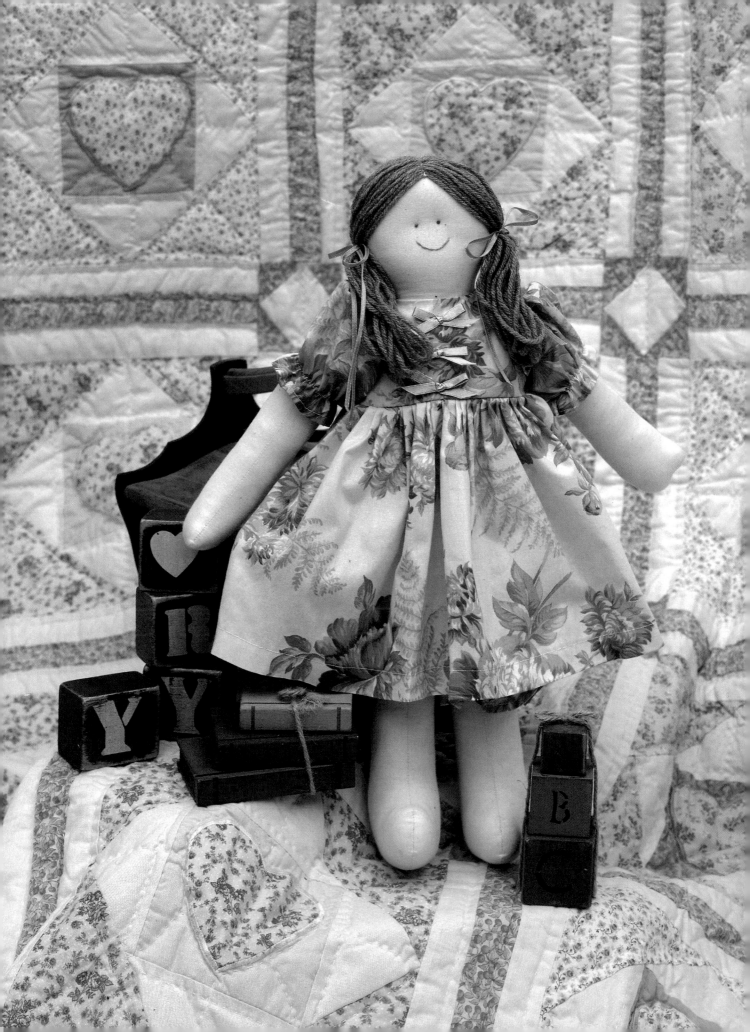

SARAH

"Won't you come and play with me?" This sweet plea is plainly written across Sarah's face. 18″ tall, Sarah would like to be friends with a little girl you know.

Supplies

♥ ⅜ yd. of cotton fabric *or* muslin for body
½ yd. of cotton fabric for dress
¼ yd. of cotton fabric for panties
1½ yds. of ⅛″ elastic
1 yd. of ⅛″ ribbon for hair
¾ yd. of ¼″ ribbon for dress front
embroidery floss: brown and rose for face
polyester fiber stuffing
approx. 5 yds. of crochet yarn for hair
matching thread for body, dress, panties, and hair
powdered blush for cheeks, if desired

To make the doll Cut out 2 body pieces, 4 arm pieces, and 4 leg pieces. With right sides together, sew around the body, arms, and legs, leaving openings where indicated. Trim the seams and clip the curves. Turn all pieces right side out and stuff them firmly.

Fold under ¼″ to the inside at the openings, and whipstitch the openings closed. Sew the legs to the body. Sew the arms to the sides of the body, with the thumbs facing forward.

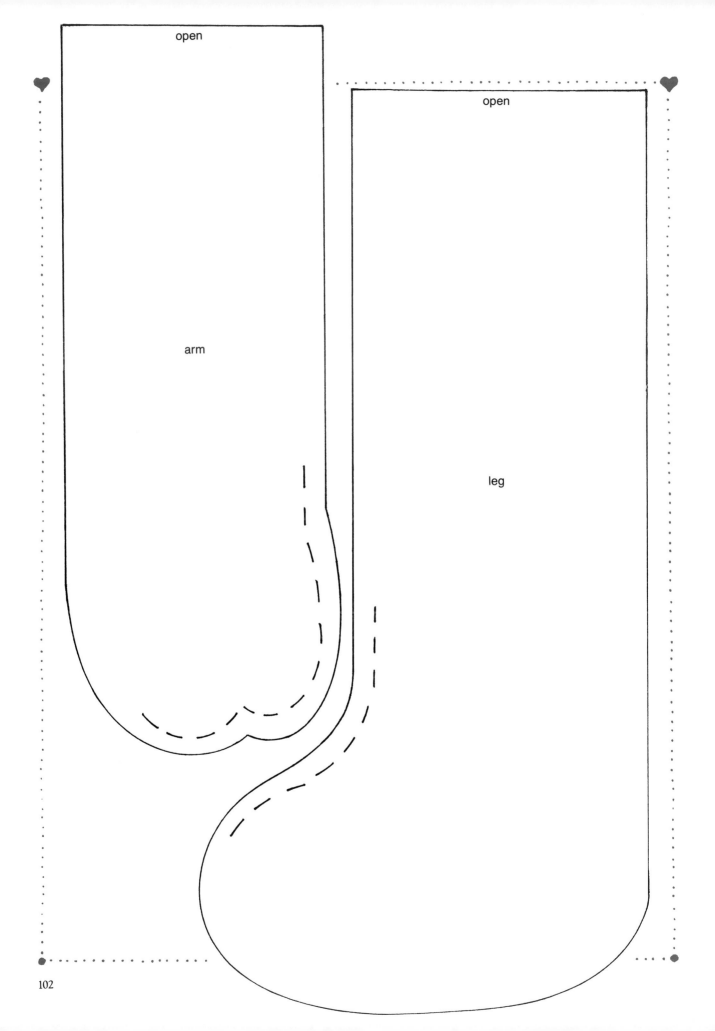

open

arm

open

leg

open

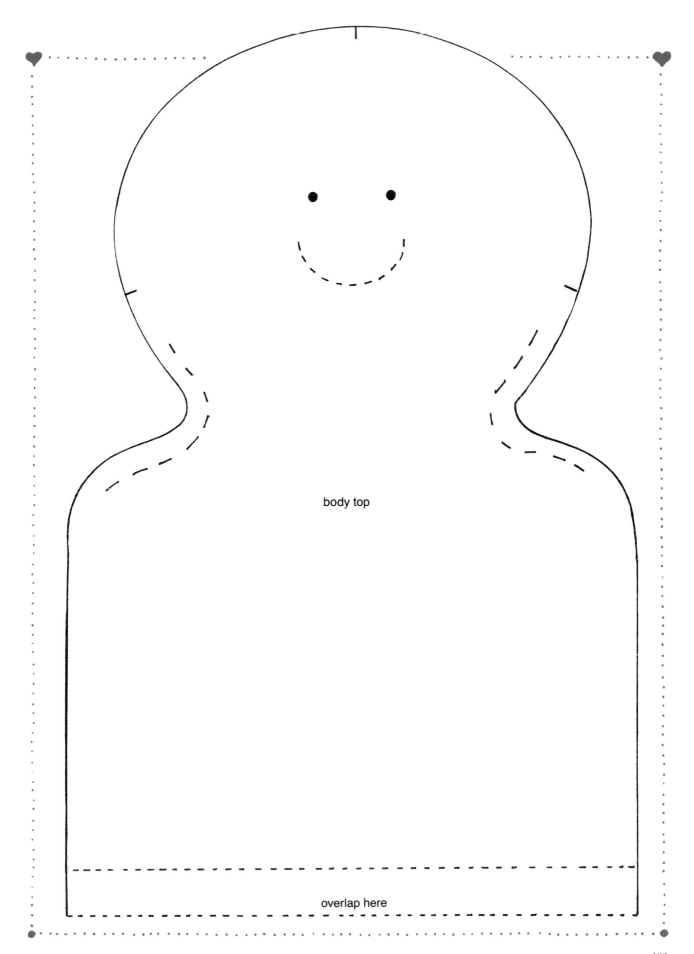

body top

overlap here

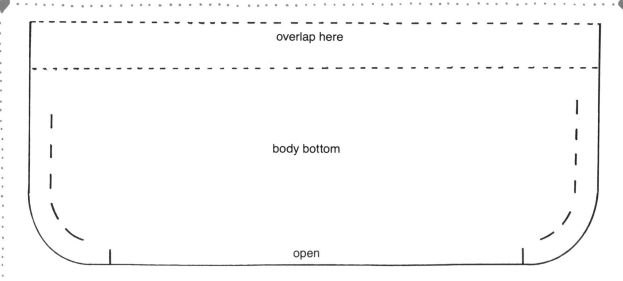

overlap here

body bottom

open

Embroider the facial features using embroidery floss. Make a French knot for each eye and pull to indent. For the mouth, cut the rose floss to the desired length and separate it into 3 strands. Using a running stitch, form the mouth. Lightly brush Sarah's cheeks with powdered blush, if you wish.

Dress Cut 2 bodice front pieces, 4 bodice back pieces, 2 sleeve pieces on the fold, and 1 skirt piece measuring 9″ × 36″. (1 of the bodice front pieces and 2 of the bodice back pieces will form the lining). With right sides together, sew

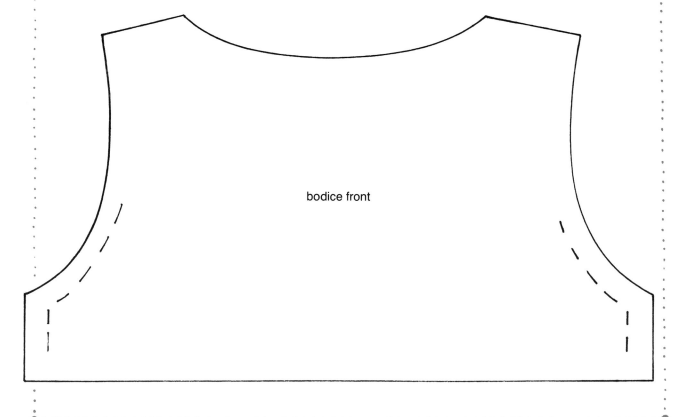

bodice front

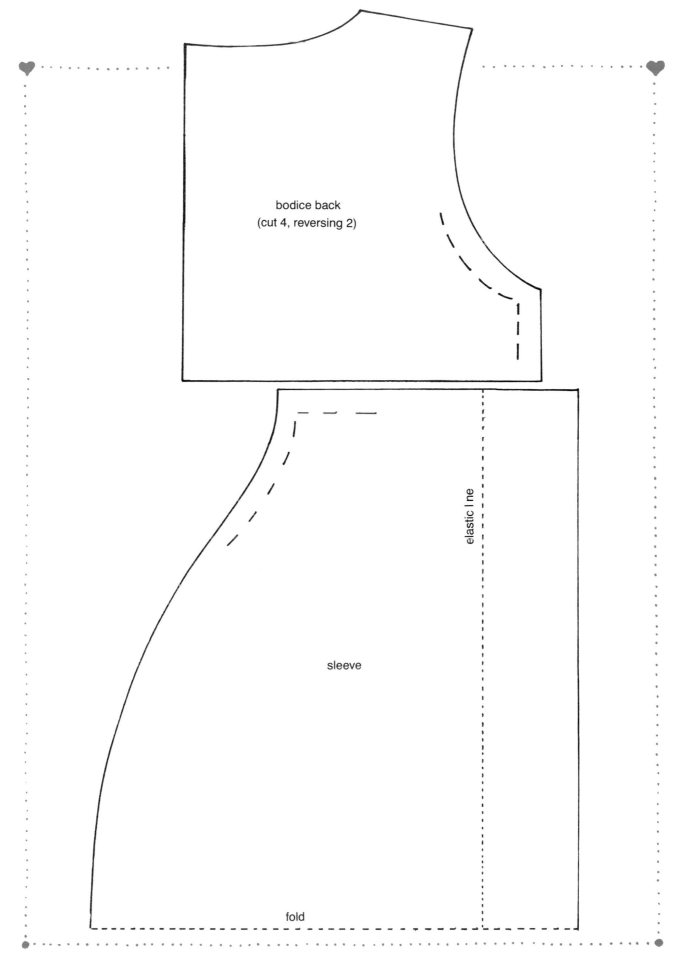

bodice back
(cut 4, reversing 2)

elastic line

sleeve

fold

waist

fold line

center front seam/
center back seam (opposite of fold)

fold

panties

inseam/
(inseam opposite of fold)

elastic line

hem

the shoulder seams of the bodice and the lining. Press the seams open. With right sides together and the bodice on top of the lining, sew up one back edge, around the neckline, and down the other back edge. Trim the seams, clip the curves, turn right side out, and press.

Narrowly hem the sleeve pieces. On the wrong side of the sleeves, stitch 5″ of elastic on the stitching line (about ⅝″ up from the hemmed edge), stretching tightly to gather. With the right sides of the sleeves facing the bodice, sew the sleeves onto the bodice, gathering the sleeve top to fit the armhole. Also with right sides together, sew the underarm seam, continuing down the bodice sides.

Stitch the back center seam of the skirt piece to within 1″ of the top edge. Gather the waist to fit and, with right sides together, sew the skirt to the bodice of the dress, leaving ¼″ of the skirt extending over the bodice backs. Make a 1″ hem on the skirt.

Turn the dress right side out and tack 3 small bows (made from the ¾ yd. of ribbon) to the center of the bodice front. Put the dress on Sarah, and tack the back closed. (If desired, fasteners can be used to secure the dress; see "General Instructions and Tips.")

Panties On the fold, cut out 2 panties pieces. Sew up both the center front and center back seams. Fold down 1″ of the top edge to the inside. To form a casing, stitch ¼″ down from the folded edge, and again ½″ down, leaving a small opening. Insert 10″ of elastic into the casing and secure the ends. Narrowly hem the legs of the panties. On the wrong side of the legs, stitch 6″ of elastic on the stitching line (about 1″ up from the hemmed edge), stretching tightly to gather. Fold the panties, right sides together, aligning the center front with the center back seam. Stitch the leg inseams from hem to hem, then turn the panties right side out. Put them on Sarah.

Hair Wrap the yarn 12 times around a piece of 15″-wide cardboard. Slide the yarn off. Lay it flat and machine stitch across the center to create a part. Sew the hair by hand to the top center and sides of Sarah's head. Tie 18″ of ribbon around each ponytail.

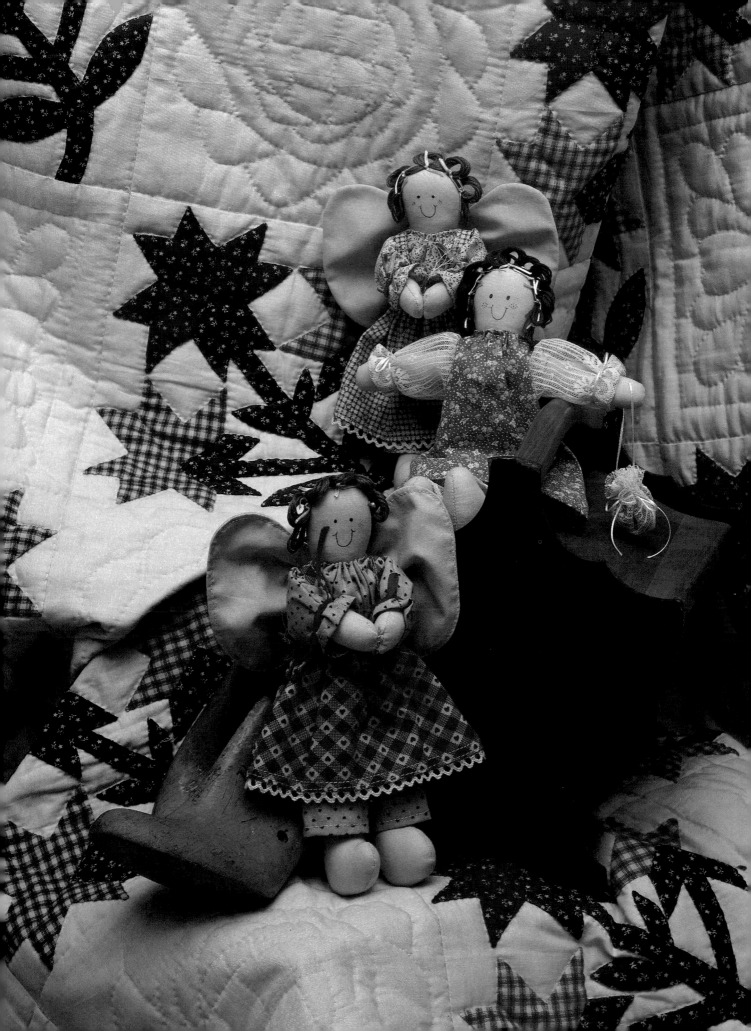

CARLY

Carly is 10″ of spunk—although she can be a real angel, too. She has quite a wardrobe: a dress, pantaloons, a jumper, and a combination blouse and bloomers. You can even make a miniature potpourri ball to place in her hand, so she'll smell as sweet as she looks.

Supplies for the doll

♥ ¼ yd. of cotton fabric *or* muslin for body
1 pkg. of embroidery floss for hair
¾ yd. of ¹⁄₁₆″ ribbon for hair
black, fine-tip permanent marking pen for face
polyester fiber stuffing
matching thread
powdered blush *or* colored pencil for her cheeks

Jumper ¼ yd. of cotton fabric for combination blouse and bloomers
¼ yd. of cotton fabric for jumper
½ yd. of narrow lace
6″ of ¹⁄₈″ elastic
½ yd. of ¹⁄₈″ ribbon for sleeves
matching thread

Dress ¼ yd. of cotton fabric for dress
¼ yd. of different cotton fabric for sleeves and pantaloons

12″ of ¹⁄₈″ ribbon for neck
½ yd. ¹⁄₈″ ribbon for sleeves
matching thread

Accessories scrap of fabric *or* lace for potpourri ball
potpourri
½ yd. of ¹⁄₁₆″ ribbon to tie ball
small bunch of dried flowers
8″ × 12″ scrap of fabric for wings
6″ × 8″ piece of fleece for wings

To make the doll Cut 2 body pieces and 4 leg pieces. With right sides together, stitch together the body pieces, leaving an opening where indicated on the pattern. Trim the seams, clip the curves, and turn the body right side out.

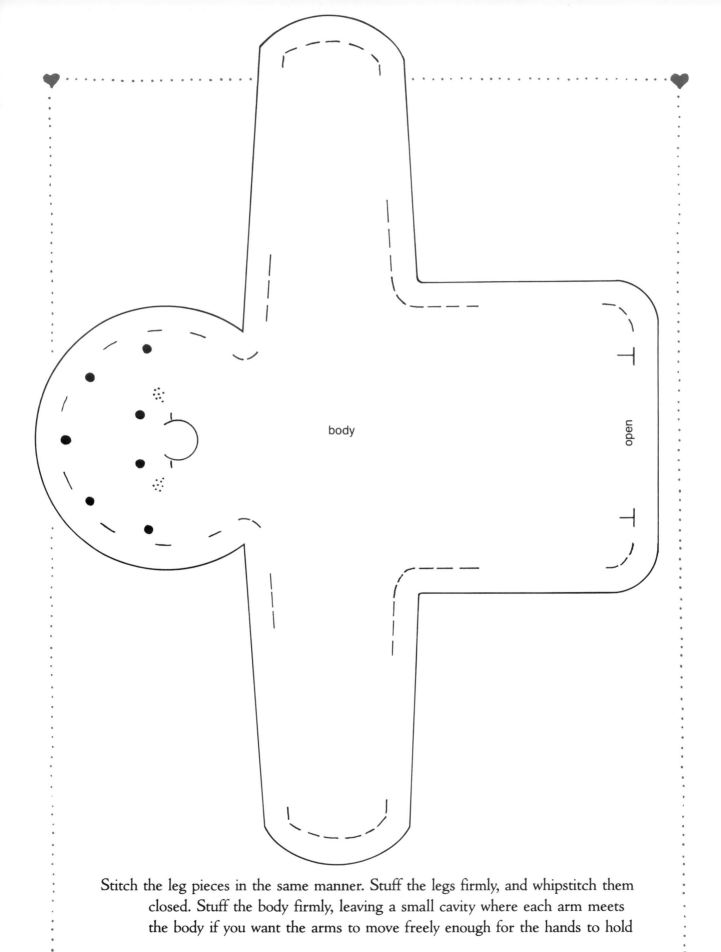

body

open

Stitch the leg pieces in the same manner. Stuff the legs firmly, and whipstitch them closed. Stuff the body firmly, leaving a small cavity where each arm meets the body if you want the arms to move freely enough for the hands to hold

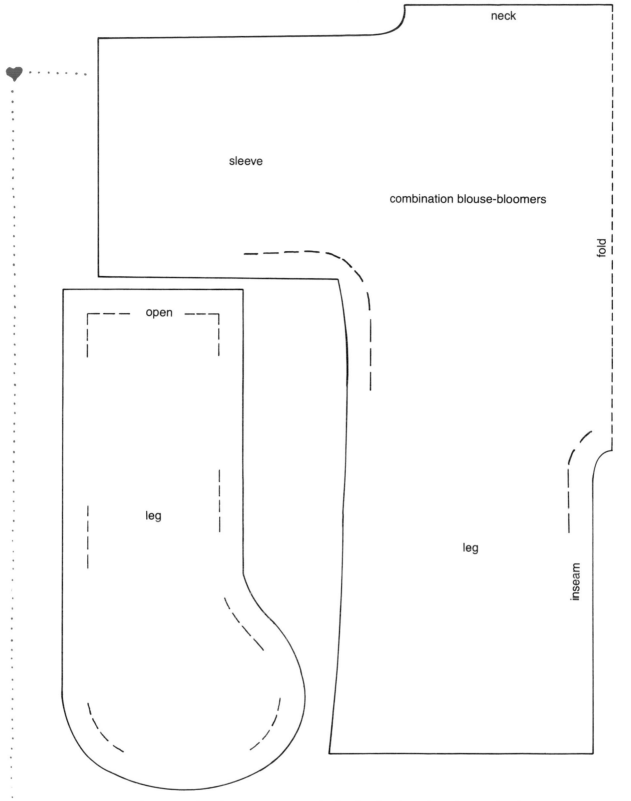

neck

sleeve

combination blouse-bloomers

fold

open

leg

leg

inseam

something at the front. Whipstitch the body closed and sew the legs to the body.

Use the fine-tip permanent pen to add the facial features. (It's wise to practice on a scrap of fabric first.) Minor differences in the smile, freckles, and eyes give each doll a unique personality. Use a little powdered blush or colored pencil to add color to her cheeks.

Jumper Cut out 2 combination blouse and bloomers pieces on the fold. With right sides together, stitch the shoulder seam. Clip the curve near the neck. Open up the sleeves and narrowly hem the edges. With right sides together, stitch the lower sleeve and the side seams to the bottom of the bloomers legs. Clip the underarm curves. Open up the legs and narrowly hem the bloomers edges. With right sides together, stitch up the inseams. Clip the curve and turn right side out.

Fold under the neck edge $\frac{1}{4}''$, run a gathering thread around the neck, and put the blouse/bloomers on the doll. Tighten up the thread and secure it. Tie an 8″ length of ribbon around each sleeve, about $\frac{1}{2}''$ up from the hemmed edges. Adjust the sleeve gathers evenly.

Cut out 1 jumper skirt piece, and stitch up the back seam. Narrowly hem the bottom edge, and stitch lace to the wrong side. Fold down $\frac{3}{4}''$ to the inside on the upper edge. Topstitch $\frac{1}{8}''$ from the folded edge, and again $\frac{3}{8}''$ from the edge (leave a small opening at the center back on the second row). Insert 6″ of elastic into the casing and secure it in the back. Cut out 2 strap pieces. Fold the straps in half lengthwise, then fold in the raw edges.

fold line

jumper skirt

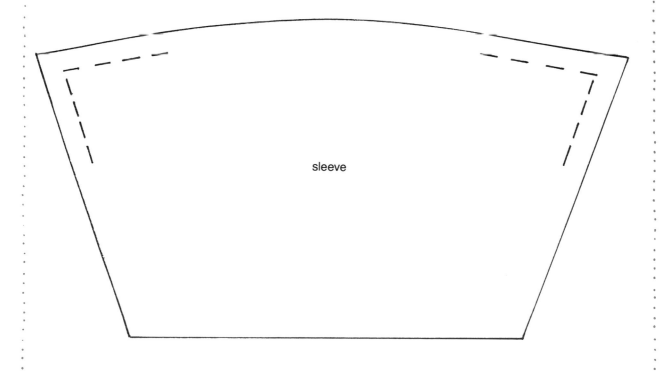

strap

Topstitch down the length. Tack the straps to the skirt section of the jumper at the front. Put the jumper on the doll, cross the straps at the back, and tack them to the inside of the skirt waist.

Dress Cut out 2 dress pieces. Cut 2 sleeve pieces from different fabric (lace works nicely).

With right sides together, stitch the shoulder seams of the dress. Clip the curves. Narrowly hem the sleeve edges. Stitch the sleeves to the dress, gathering them at the shoulder seams. With right sides together, stitch the sleeve and side seams. Clip the underarms. Turn the dress right side out, and hem the bottom edge of the dress. Fold under ¼″ at the neckline and run a

sleeve

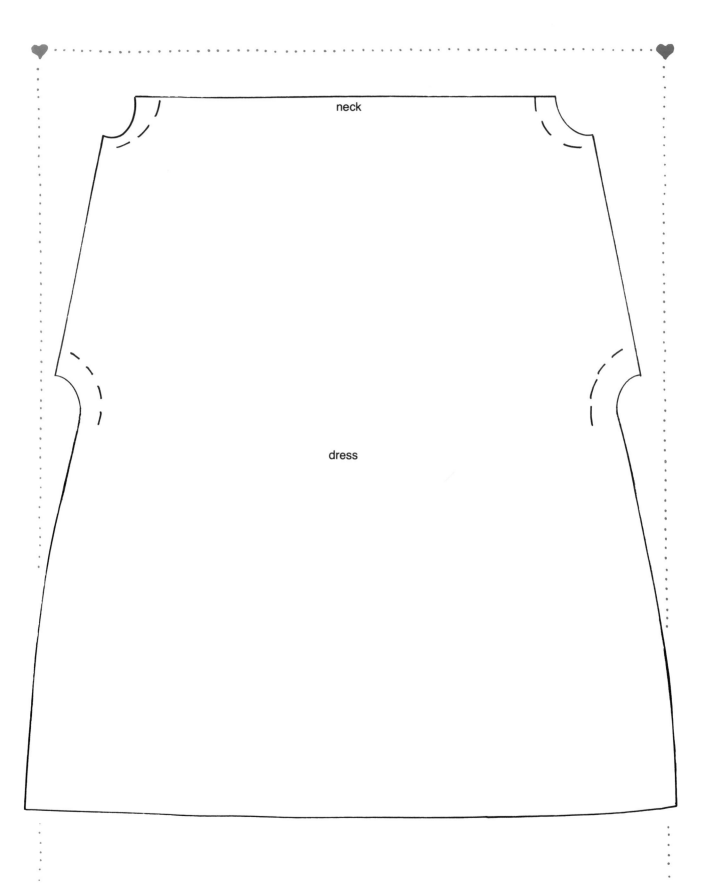

neck

dress

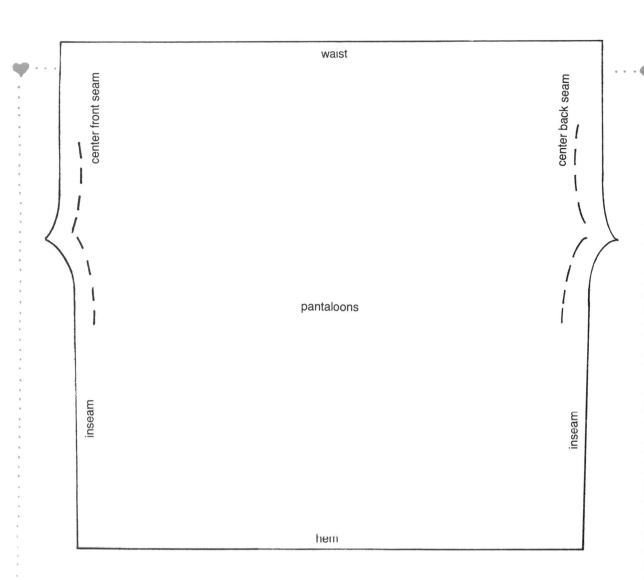

waist

center front seam

center back seam

inseam

inseam

pantaloons

hem

gathering thread around it. Put the dress on the doll, pull the thread and secure it. Tie an 8″ length of ribbon around each sleeve, about ½″ up from the hemmed edge. Adjust the sleeve gathers evenly. Tie a 12″ length of ribbon around the neckline.

Pantaloons Cut out 2 pantaloon pieces. Narrowly hem each leg. Fold each lengthwise, wrong side out, aligning the inseam edges, and stitch the inseam. Turn one leg right side out and insert it into the other leg, aligning the raw edges and matching the inseams. Stitch the crotch from waist to waist across the inseam. Turn the pantaloons right side out. Fold under ½″ at the waist and run a gathering thread around it. Put the pantaloons on the doll, and tighten and secure the thread.

Hair Wrap the floss around a 12″-wide piece of cardboard 4 times. (There will be 8 strings.) Using a blunt needle, thread a 4″ piece of ribbon through Carly's head at each of the 5 spots marked on the pattern. Find the *center* of your

wrapped floss, wrap it around your finger once, and give it a twist. You should have a small circle of floss with an equal amount hanging on each side. Carefully lay this loop over the ribbon at the top of the head, pull one end of the ribbon through the loop, and tie it in a half knot. (Don't tie the rest of the knot yet, in case you have to make some adjustments.)

Continue making and securing a loop at each ribbon. When you have completed both sides, you should have fairly even curls. Finish tying the knots and trim off the excess ribbon. If you'd like to give Carly even more curls, stagger another row of loops directly behind the first row.

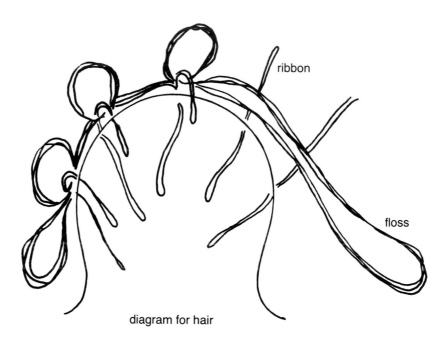

ribbon

floss

diagram for hair

Potpourri Cut out a 4½″ circle from lace or other fabric. Run a gathering thread or thin ribbon around the outside, about ½″ from the edge. Fill the center with potpourri, draw the thread or ribbon tight and secure it. String a ribbon through the neck of the potpourri ball and sew the ribbon to Carly's arm.

Alternatively, sew a small bouquet of dried flowers between Carly's hands.

Wings To make Carly extra angelic, cut out 2 wing pieces from cotton fabric and 1 from fleece. With right sides together and the fleece underneath, stitch around the wings, leaving an opening where indicated. Trim the seam allowances, turn the wings right side out, press, and whipstitch the opening closed. Make 3 pleats by folding the wings on the solid lines, and bringing the folds up to the dotted lines. Pin, then stitch down the center. Tack the wings to the back of Carly's dress.

wings

open

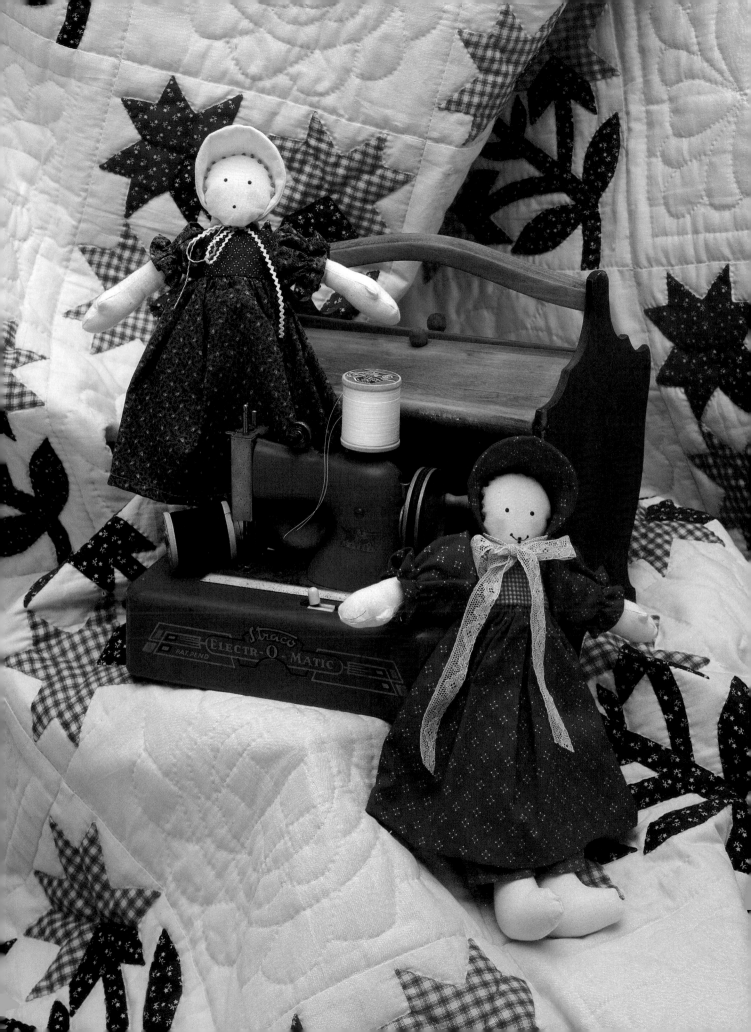

OLIVIA

Demure and pretty, Olivia stands about 12″ tall. Her puff sleeves, pantaloons, and bonnet all add to her quaint charm. Olivia is far from fragile, though—she'd love to have a hug from you or a young friend.

Supplies

- ¼ yd. of cotton fabric *or* muslin for body
- 5″ × 10″ piece of cotton for bonnet
- ¾ yd. of thin lace *or* rickrack for bonnet ties
- ¼ yd. of cotton fabric for dress
- 8″ × 12″ piece of cotton fabric for pantaloons
- 6″ × 10″ piece of different cotton fabric for bodice
- polyester fiber stuffing
- 12″ of ¼″ wide elastic
- black, fine-tip permanent marking pen for face
- powdered blush for cheeks, if desired
- 3-ply crewel yarn for hair
- matching thread for body, bonnet, pantaloons, and dress

To make the doll Cut out 2 head pieces, 2 body pieces, 4 arm pieces, and 4 leg pieces. With right sides together, stitch the head pieces, leaving an opening where indicated on the pattern. Turn the head right side out, stuff firmly, and whipstitch the opening closed.

With right sides together, stitch the body pieces, leaving an opening where indicated. Turn right side out, stuff firmly, and whipstitch the opening closed. Again with right sides together, stitch the arm pieces and leg pieces, turn them right side out, stuff firmly, and whipstitch the openings closed. Sew the arms (with thumbs facing outward) and legs to the body where indicated.

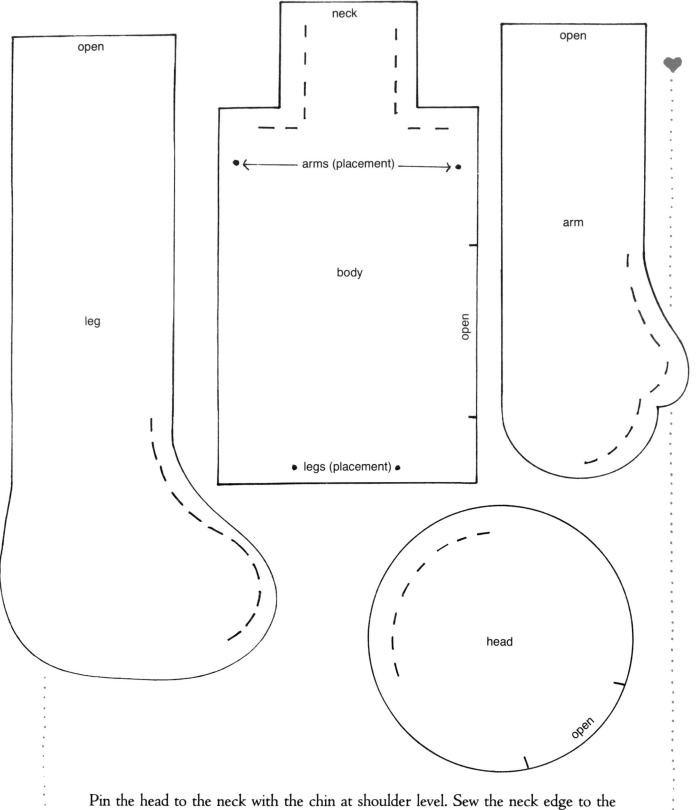

Pin the head to the neck with the chin at shoulder level. Sew the neck edge to the back of the head. Use one strand of the crewel yarn to make French knots around the head, slightly forward of the head seam. Mark the eyes and mouth with pins to note the placement. When you are happy with her expression, use the marking pen to make the eyes and mouth. Lightly brush blush on the cheeks, if desired.

Pantaloons Cut out 2 pantaloon pieces. With right sides together, stitch the front seam of the pantaloons. Press down ½″ to the wrong side around the waist. Stitch ⅜″ from the edge. Insert 4½″ of elastic and secure the ends. Stitch the center back seam. Narrowly hem the legs. Fold the pantaloons, right sides together, aligning the center front with the center back seam. Stitch the leg inseam from hem to hem. Turn the pantaloons right side out and put them on the doll.

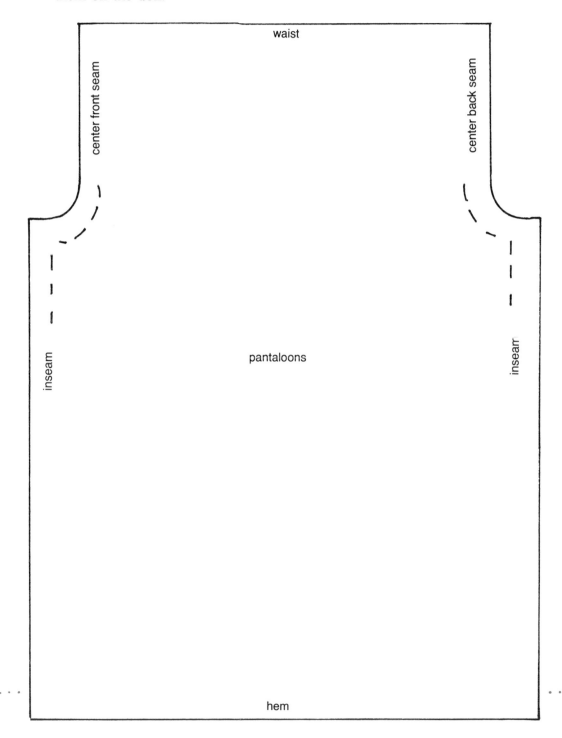

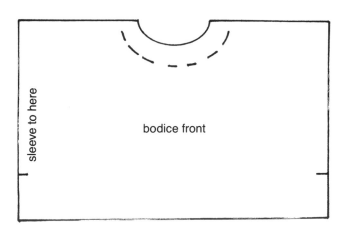

sleeve to here

bodice front

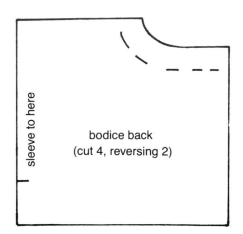

sleeve to here

bodice back
(cut 4, reversing 2)

Dress Cut out 2 bodice front pieces and 4 bodice back pieces (one set of bodice pieces will make the lining), 2 sleeve pieces (each $3'' \times 6\frac{1}{2}''$ for short or $4\frac{1}{4}'' \times 6\frac{1}{2}''$ for long), and 2 skirt pieces each $7\frac{1}{8}'' \times 9\frac{5}{8}''$. For the bodice and bodice lining, place right sides together and stitch each front piece to a back piece at the shoulders. With right sides together, stitch the dress bodice to the lining, up one back bodice piece, around the neck edge, and down the other back bodice piece. Clip the curves, turn right side out, and press. Overlap the left and right back bodice sides $\frac{1}{4}''$ and tack one to the other.

Narrowly hem the sleeve edges. Stitch $2\frac{3}{4}''$ of elastic to the wrong side of the sleeve, about $\frac{1}{2}''$ from the hemmed edge, stretching tightly as you sew to gather. With right sides together, sew the sleeves into the armholes between the marks on the pattern.

Gather the tops of the skirt pieces and stitch one to the front bodice piece and one to the back bodice piece. Stitch the underarm seams from the sleeve edges to the bottom of the skirt. Narrowly hem the skirt bottom. Put the dress on Olivia and tack it in the back.

Bonnet Cut out 2 bonnet pieces. Sew a dart in each bonnet piece. To make the ties, cut the lace or rickrack in two and pin each strip to one side of the bonnet. With right sides together, stitch together the bonnet pieces, leaving an opening where indicated. Turn right side out, whipstitch the opening closed, and tie the bonnet on Olivia's head.

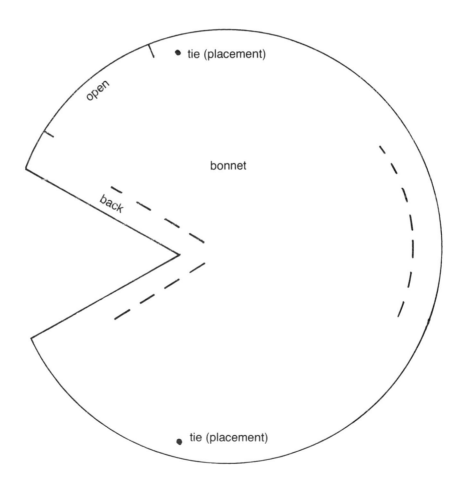

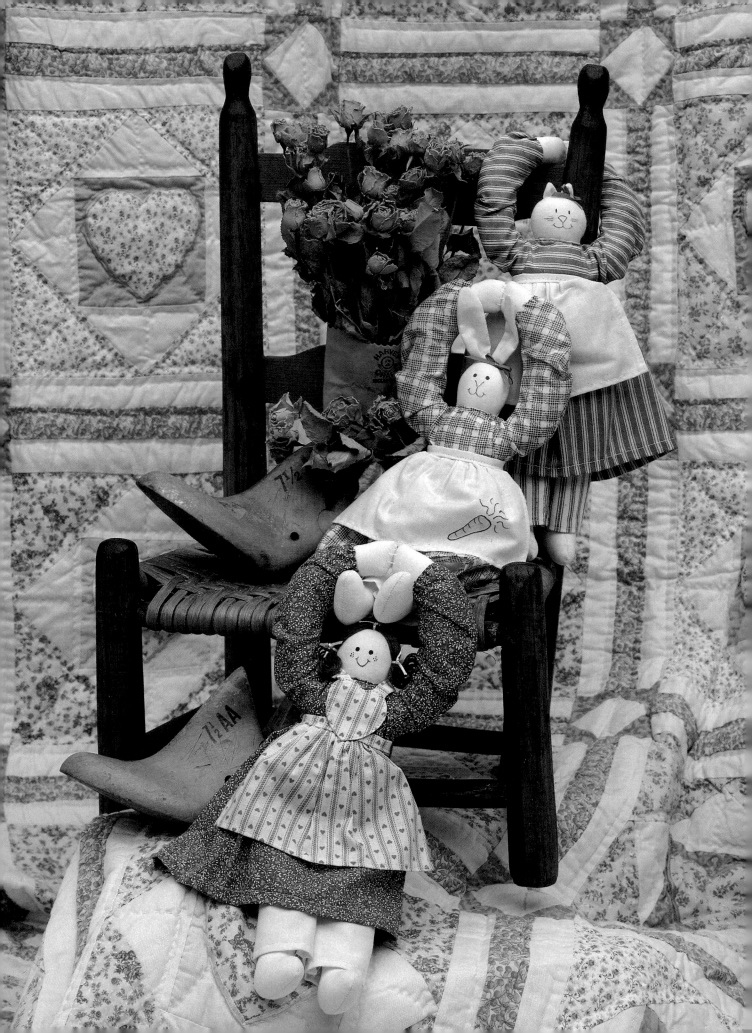

CANDEE AND FRIENDS

Candee and her friends would love to hang around your house. Each of these happy-go-lucky dolls is 14″ tall, and can swing from a doorknob, cabinet handle, Shaker peg—any spot in the house where you'd like to add a touch of down-home charm.

Supplies for one doll

¼ yd. of cotton fabric *or* muslin for body

¼ yd. of cotton fabric for dress

¼ yd. of different cotton fabric for pantaloons

⅛ yd. of different cotton fabric for apron
 (*or* use muslin scraps left over from doll body)

polyester fiber stuffing

1 skein of embroidery floss for Candee's hair

heavy thread (quilting thread)

fine-tip permanent marking pens *or* acrylic paints
 and fine brushes: black, brown, and rose for faces

colored pencils for shapes on aprons (optional)

¼ yd. of ¼″ ribbon for ears *or* hair (optional)

matching thread for body, dress, bloomers, and apron

powdered blush for face, if desired

To make each doll Cut 2 body pieces, 4 leg pieces, and, for animals, 4 ear pieces. For the cat or bunny, first sew the ear pieces with the right sides together, turn them right side out, and press. Fold each ear on the line indicated and baste to form a pleat. With the right sides together, stitch the body pieces, with the ears inserted at the points indicated on the pattern. Trim and clip the seams well, then turn right side out. Stuff the body and whipstitch the bottom opening closed.

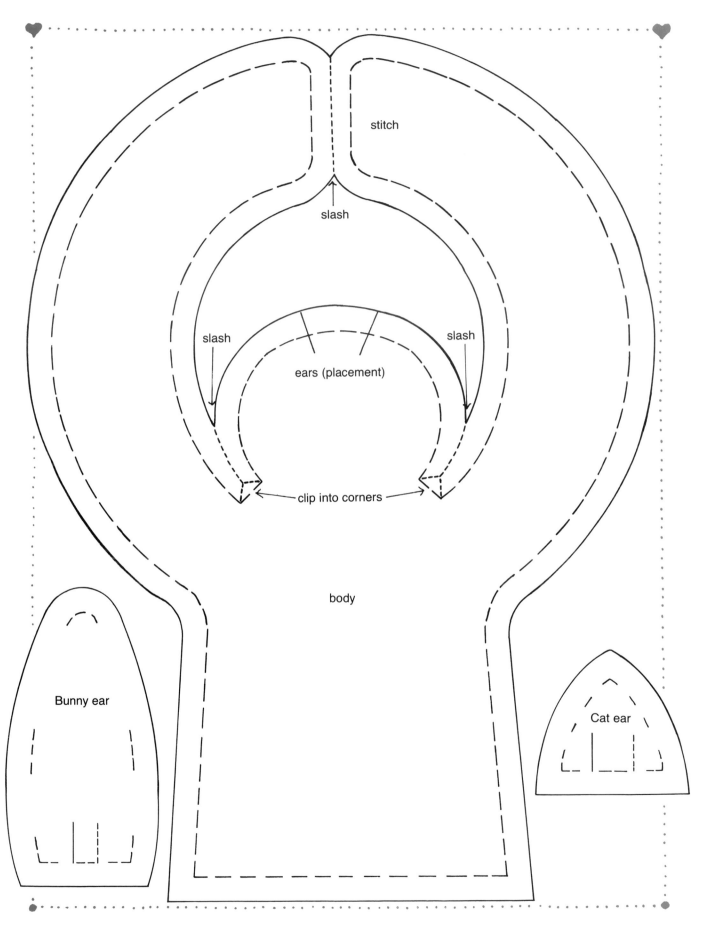

stitch

slash

slash

ears (placement)

slash

clip into corners

body

Bunny ear

Cat ear

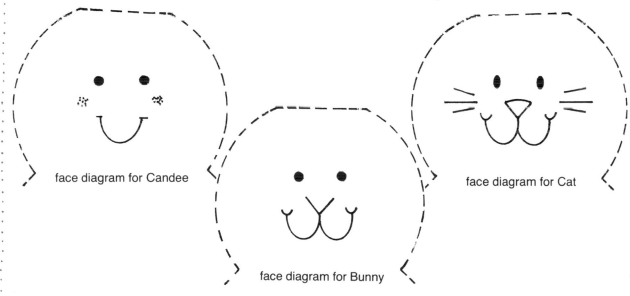

open

leg

Stitch the leg pieces, right sides together. Turn them right side out, stuff them, then whipstitch the tops closed. Sew the legs to the body.

Follow the guide to draw or paint the facial features. Use brown for the eyes and freckles on Candee and for the eyes on the bunny. Use black for the eyes and whiskers on the cat. Use rose for all the dolls' mouths. Apply powdered blush to the cheeks with a small brush or cotton swab, if desired.

face diagram for Candee

face diagram for Bunny

face diagram for Cat

Pantaloons Cut out 2 pantaloon pieces. Narrowly hem each leg. Fold each lengthwise, wrong side out, aligning the inseam edges, and stitch the inseam. Turn one leg right side out and insert it into the other leg, aligning the raw edges and matching the inseams. Stitch the crotch from waist to waist across the inseam. Turn the pantaloons right side out. Fold under ½″ at the waist and run a gathering thread around it. Put the pantaloons on the doll, and tighten and secure the thread.

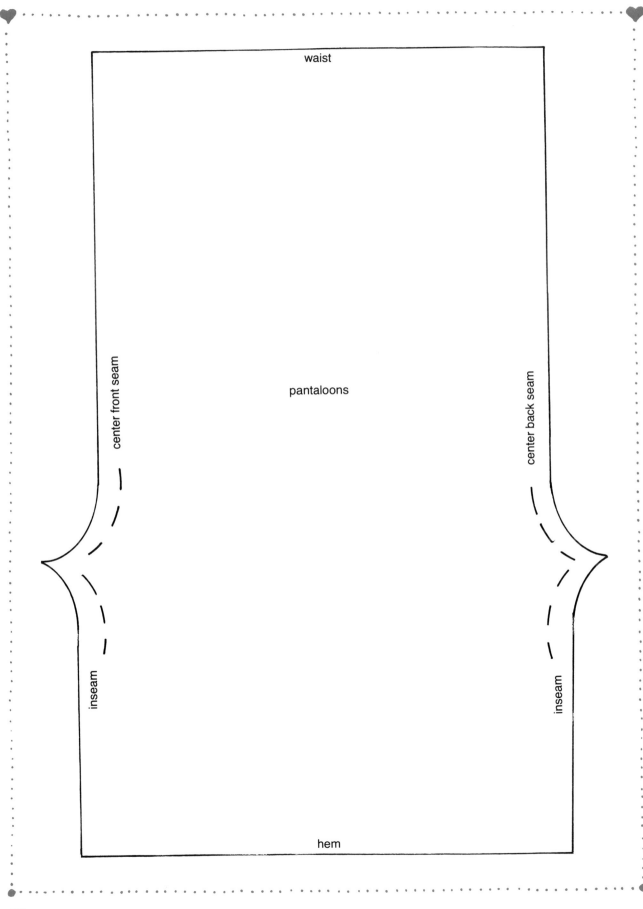

waist

pantaloons

center front seam

center back seam

inseam

inseam

hem

Dress Cut out 2 dress top pieces, and 1 skirt piece measuring $6\frac{1}{2}'' \times 18''$. With right sides together, stitch the shoulder/upper arm seams. Leave the neck open where indicated.

open

dress top

Stitch *one* lower sleeve edge down to the waist. Gather the top edge of the skirt and stitch it to the bodice with the right sides together. Stitch the other lower sleeve, continuing down to the bottom of the dress. Clip the underarm areas, then turn the dress right side out. Narrowly hem the lower edge of the dress.

apron

Fold under ¼″ of the raw edge at the neckline and sleeves. Run a gathering thread through, put the dress on the doll, and tighten and secure the threads. Using heavy thread, tack the hands together.

Apron Cut out 1 apron piece and a 1¼″ × 20″ piece of fabric for the apron band and tie. Narrowly hem the sides and bottom of the apron. On the cat's or bunny's apron, you may wish to trace the mouse or carrot designs provided. An easy method is to hold the fabric up to a window with the drawing underneath. Colored pencil works well if you choose to color the designs.

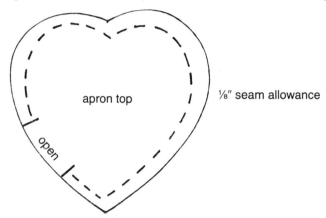

Gather the apron at the top to measure 3″. Fold the tie in half lengthwise, and press. Fold the raw edges in and press again. Center the gathered apron on the folded tie and topstitch the length of the tie. This completes the apron for the cat or bunny.

For Candee, cut 2 heart apron-top pieces and put them right sides together. Using a ⅛″ seam, stitch the pieces together, being sure to leave the opening marked on the pattern. Turn right side out, press, and edgestitch around the heart. Tack the point of the heart to the front center of the apron. Cut a 1″ × 13″ piece of the apron fabric for a strap. Fold this piece in half lengthwise, press it, then fold the raw edges in and press it again. Topstitch the length, and cut the strap in half. Tack each piece to the top of the heart, cross the straps in the back, and tack the ends to the apron band after you have tied it on the doll.

Candee's hair Wrap embroidery floss around a 5″ piece of cardboard (a 3″ × 5″ card works well) 16 times. Slide the floss off the cardboard and pinch and tack it to the top center of the doll's head. Pinch and tack the hair once on each side to make ponytails. If you wish, use the ¼″ ribbon to tie bows in Candee's hair and to make bows to tack to the cat's and bunny's ears.

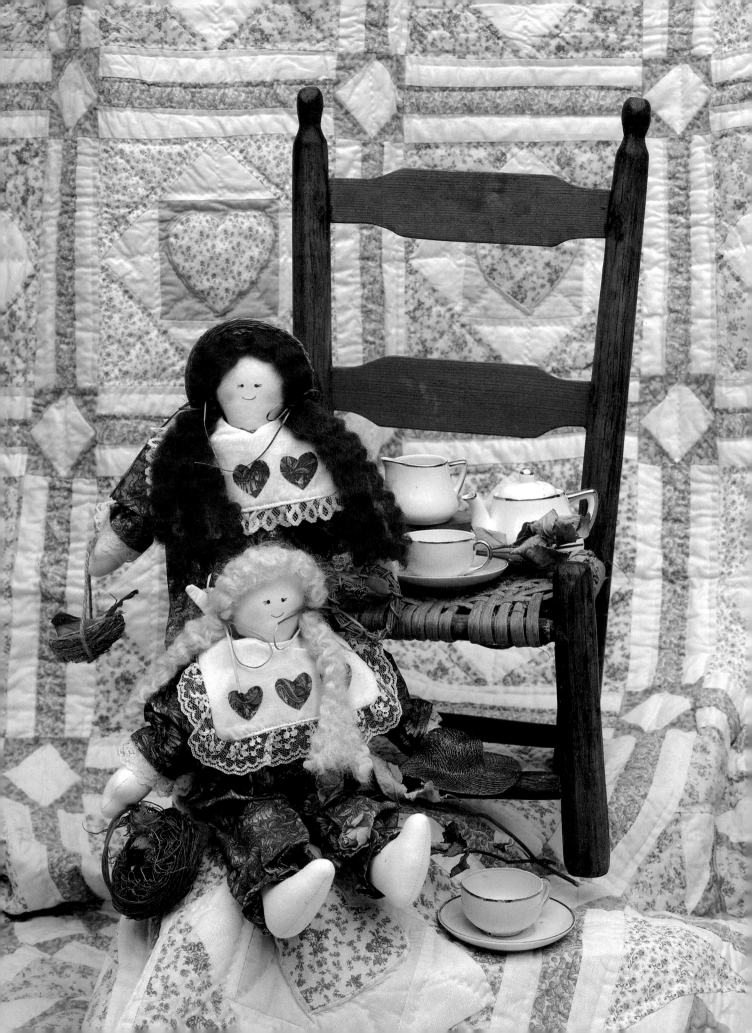

BELLE

Belle is aptly named: With her wavy tresses and sunny smile, she's pretty and engaging. She has even charmed the birds out of the trees! Belle, who is 14″ tall, wears an easy-to-make jumpsuit dressed up with an appliquéd collar.

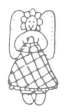

Supplies

♥ ¼ yd. of cotton fabric *or* muslin for body

polyester fiber stuffing

black, fine-tip permanent marking pen for face

powdered blush for cheeks, if desired

⅜ yd. of cotton fabric for jumpsuit

¼ yd. of cotton fabric *or* muslin for collar

½ yd. of ½″ flat lace for jumpsuit

½ yd. of ⅛″ elastic

scraps of different fabric for hearts on collar

small piece of transfer web (for appliqués)

¼ yd. of ⅛″ ribbon for collar

¾ yd. of 1″ gathered lace for collar

6″ of crepe wool hair

¾ yd. of 1/16″ ribbon for hair

matching thread for body, jumpsuit, and collar

small straw hat (optional)

small wreath (optional)

3″ bird's nest with small bird and eggs (optional)

To make the doll Cut out 2 body pieces, 4 leg pieces, and 4 arm pieces. With right sides together, stitch the body, leaving an opening where indicated on the pattern. Stitch the leg pieces and arm pieces, with right sides together

and leaving openings where indicated. Clip the curves, turn all pieces right side out, and stuff firmly. Stop stuffing the arms and legs about ¾″ from the top.

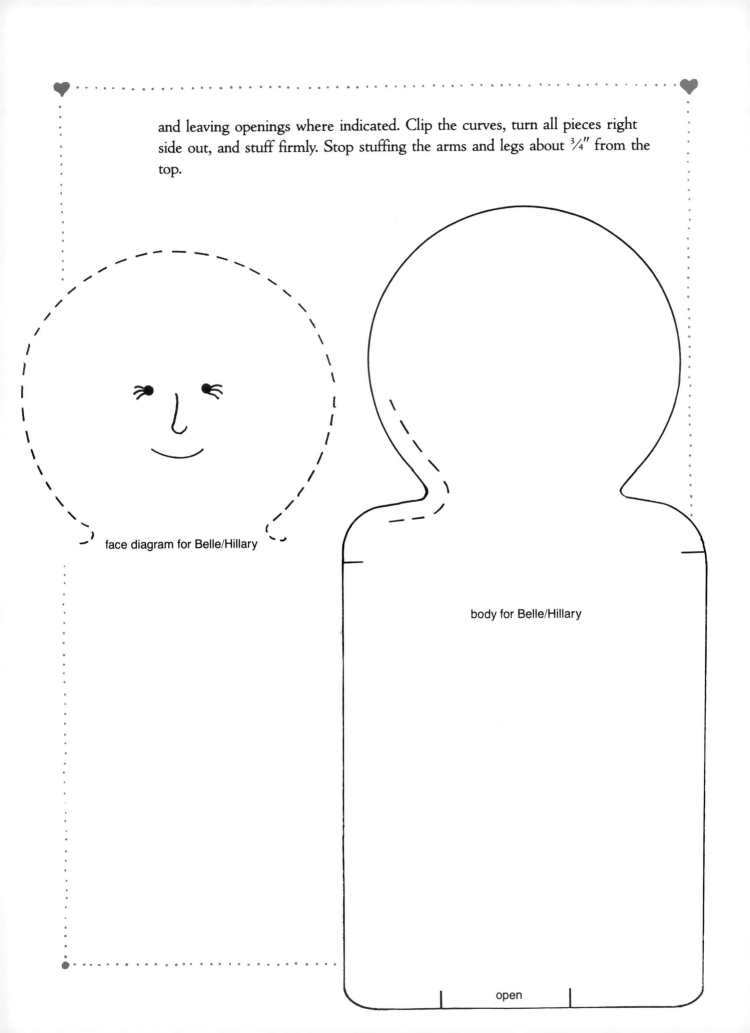

face diagram for Belle/Hillary

body for Belle/Hillary

open

Whipstitch the bottom of the body closed. Turn under ¼″ to the inside at the top of each arm and leg, sew the limb closed, then sew it to the body. Carefully draw the face using a black, thin-line marker. You may wish to practice on a scrap of fabric before attempting the doll's face. Lightly brush powdered blush on the cheeks, if desired.

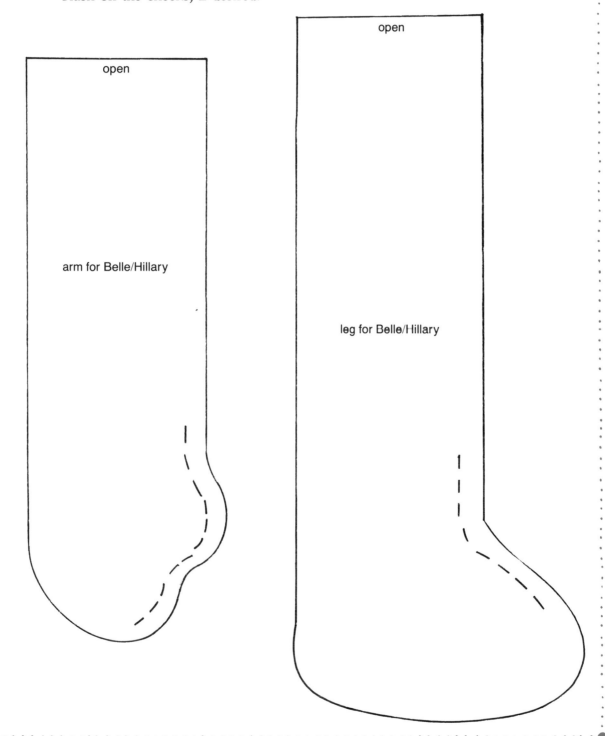

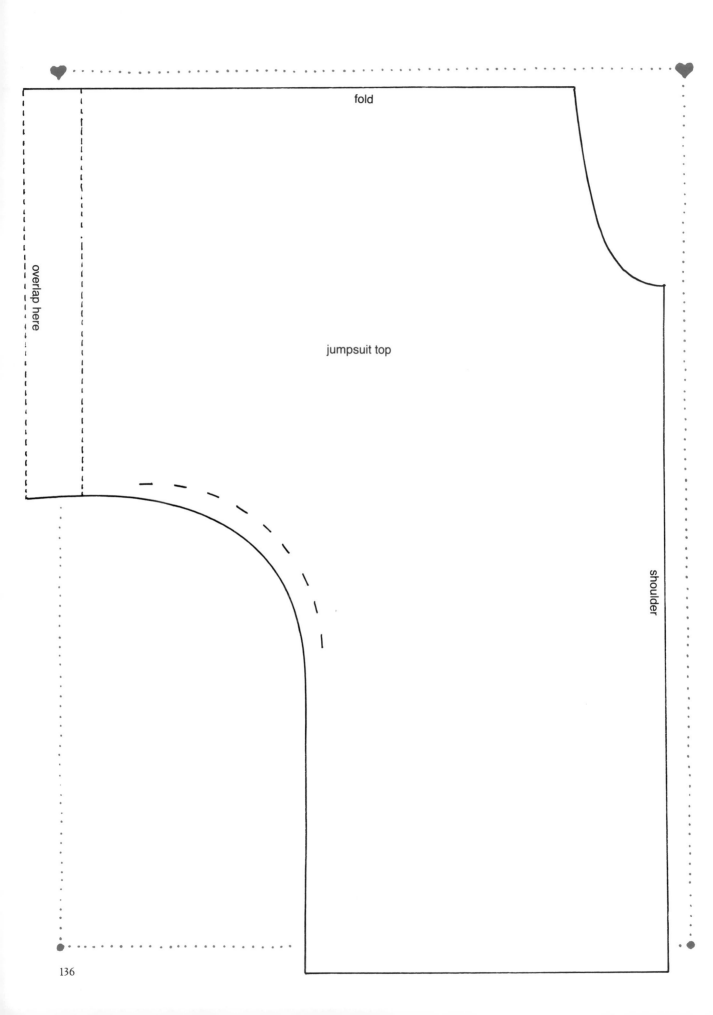

fold

overlap here

jumpsuit top

shoulder

hem

jumpsuit bottom

fold

overlap here

inseam

Belle's jumpsuit Overlap the jumpsuit patterns where indicated and cut out 2 jumpsuit pieces on the fold. With right sides together, stitch the shoulder seams. Narrowly hem the sleeves, then sew the lace to the inside edge. On the wrong side, sew 3¼" elastic ⅝" up from the hemmed edge, stretching tightly as you sew, to gather. Stitch the underarm seams and side seams. Narrowly hem the leg bottoms. Sew 3¾" elastic at ankles, as you did for the wrists. Fold the jumpsuit, right sides together, aligning the center front with the center back seam. Stitch the leg inseam from hem to hem. Fold under ¼" at the neck and run a gathering thread around it. Put the jumpsuit on Belle, tighten the thread, and secure it.

Cut out 2 collar pieces. Following the manufacturer's directions, cut and fuse the hearts to the collar where indicated on the pattern. Sew lace to the collar's edge, where indicated on the pattern. With right sides together, stitch together the collar pieces, leaving an opening where indicated. Turn the collar right side out and press. Stitch the opening closed. Put the collar on Belle and tie the ribbon in a bow at the back. You may need to tack the collar to the top front edge of the jumpsuit to keep it from shifting.

Hair Carefully unravel and fluff as much of the 6" of crepe wool hair as you wish to use. Tack the hair to the middle of the top and the sides of Belle's head. Tie a 13" length of ribbon to each side. If desired, tack a hat to Belle's head or hand, give her a small wreath, and a bird in a nest.

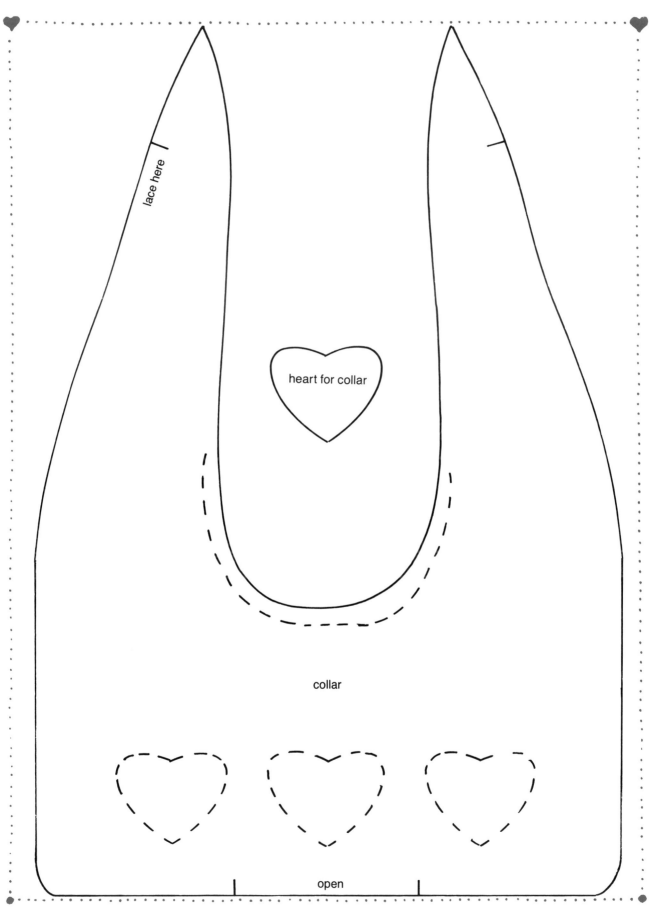

lace here

heart for collar

collar

open

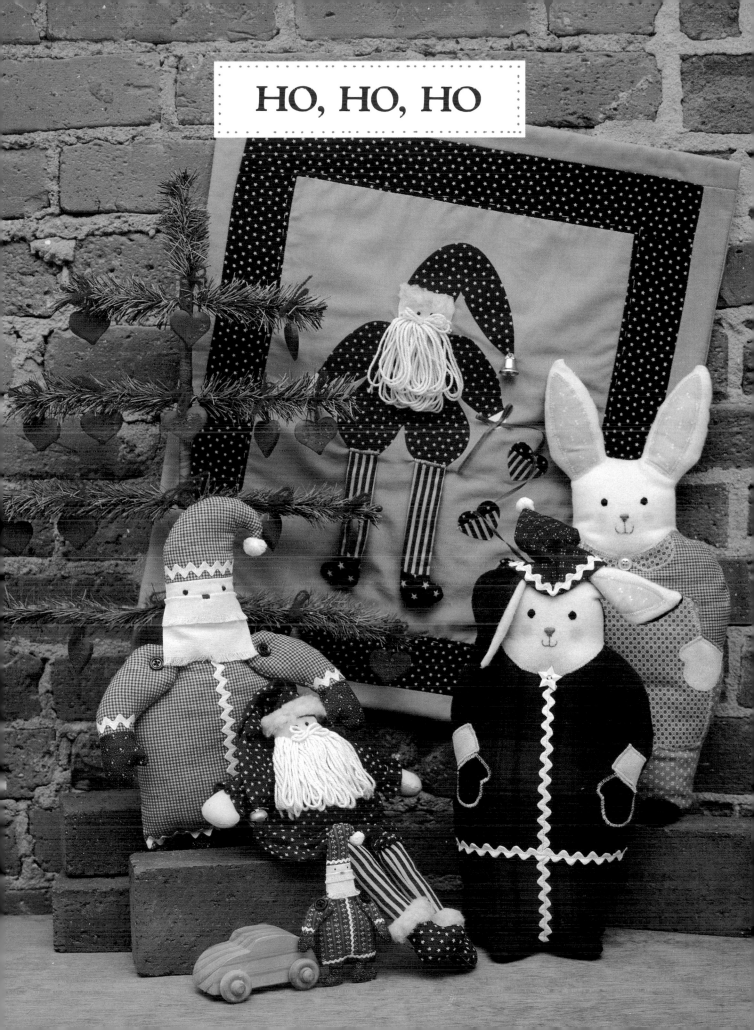

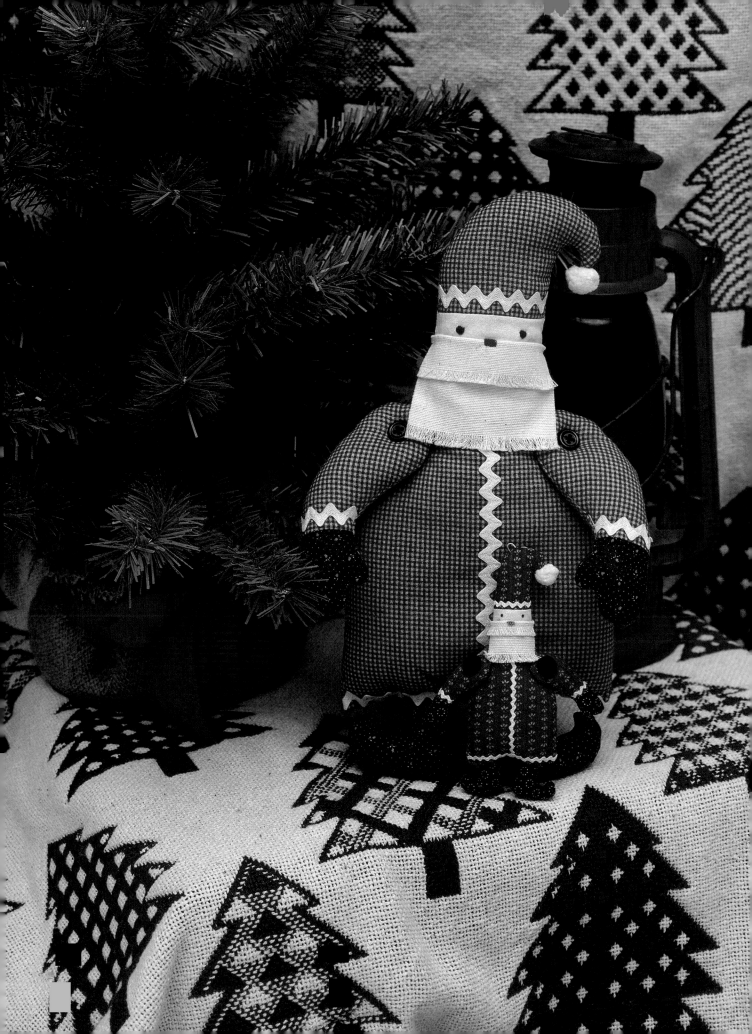

COUNTRY ST. NICK

Ho, ho, ho! Christmas can't be far away when these decorative Santas appear. The large Santa (14″ tall) will stand on a mantel or lean against a stack of presents. The small Santa (5″ tall) is perfect for hanging on the tree or stuffing in a stocking.

Supplies for large Santa

6″ × 4″ piece of muslin for head

¼ yd. of red print cotton fabric for body, arms, and hat

6″ × 14″ piece green print cotton fabric for mittens and boots

scrap of heavy, natural-color cotton fabric for beard

2 black buttons for arms (approx. ½″)

1 yd. of ¼″ ecru rickrack

⅝″ pom-pom

polyester fiber stuffing

matching thread

embroidery floss: red and black for face

powdered blush for cheeks, if desired

liquid fray preventer *or* white glue for beard

string for hanging loop (optional)

Supplies for small Santa

scrap of muslin for head

8″ square of red print cotton fabric for body, arms, and hat

6″ square of green print cotton fabric for mittens and boots

scrap of heavy, natural-color cotton fabric for beard

2 black buttons for arms (approx ⁷⁄₁₆″)

½ yd. of ecru baby rickrack

⅜" pom-pom

polyester fiber stuffing

matching thread

fine-tip permanent marking pens: red and black for face

liquid fray preventer *or* white glue for beard

string for hanging loop (optional)

To make either Santa Cut 2 head pieces from the muslin; cut 2 body pieces, 2 hat pieces, and 4 arm pieces from the red print. Cut 4 mitten pieces and 4 boot pieces from the green print. Cut 1 beard piece from the heavy cotton. Sew rickrack down the center of the front of the body. Sew rickrack across the bottom of the body front about ½" up from where back and front will be sewn together. Sew rickrack to the front of each arm, ½" from the edge. (For the small Santa, sew all rickrack ¼" from the edge.)

With right sides together, stitch the head front pieces and back pieces to the hat front pieces and back pieces, then press open the seams. With right sides together, sew the heads to the body pieces. Press open the seams. Sew the boot pieces to the body pieces where indicated. Press the seams toward the boots.

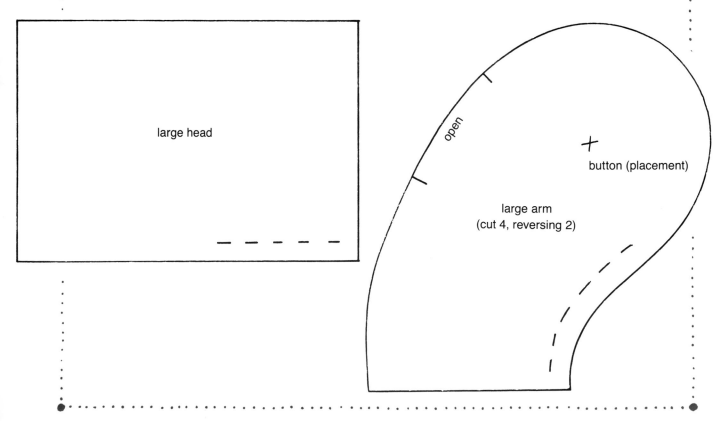

large head

open

button (placement)

large arm
(cut 4, reversing 2)

For the large Santa: Place the right sides of the body pieces together and stitch completely around, leaving an opening where indicated to turn. Turn Santa right side out, stuff, and close the opening.

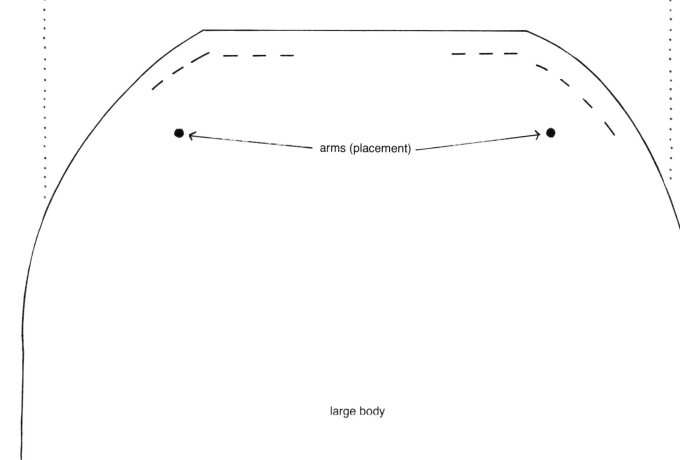

arms (placement)

large body

boots (placement)

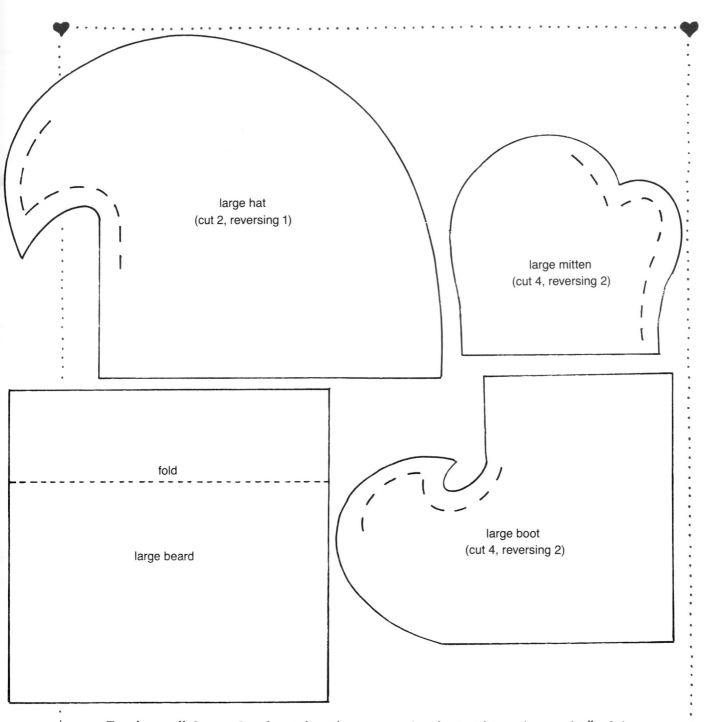

large hat
(cut 2, reversing 1)

large mitten
(cut 4, reversing 2)

fold

large beard

large boot
(cut 4, reversing 2)

For the small Santa: On the right side, turn up (to the inside) and press ³⁄₁₆″ of the red fabric on the upper layer of the boot/body seam so the boots can be seen. With right sides together, stitch Santa together. At the boot/body seam, stitch close to the fold of fabric. Leave an opening at the side. Turn Santa right side out, stuff, then close the opening.

Continue for either Santa: With right sides together, sew the mitten pieces to the arm pieces. Press the seams open. With right sides together, stitch both

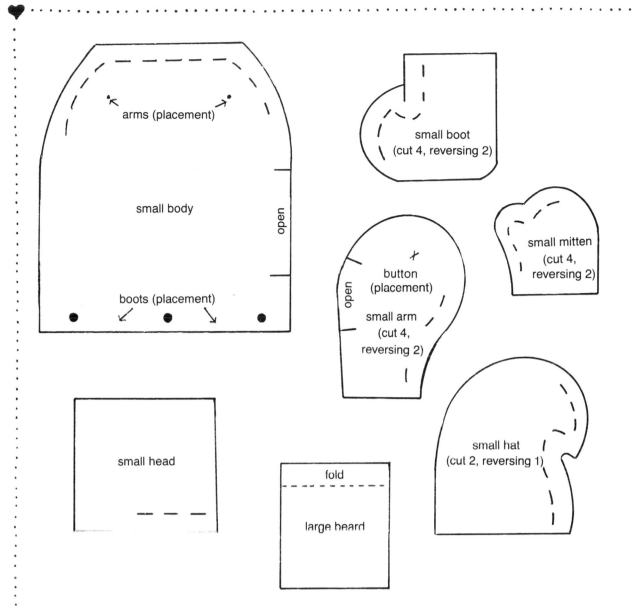

arms (placement)

small body

open

boots (placement)

small boot
(cut 4, reversing 2)

small mitten
(cut 4,
reversing 2)

button
(placement)

open

small arm
(cut 4,
reversing 2)

small head

fold

large beard

small hat
(cut 2, reversing 1)

arms, leaving an opening in each. Turn the arms right side out, stuff them, then close the openings. Align the buttons and arms on the body as marked on the patterns. Then sew the buttons and arms to the body.

Sew a pom-pom to the tip of the hat. Fray the top and bottom of the beard fabric about ¼″. If desired, apply fray preventer or diluted white glue to the edges. Let the beard dry. Fold down the beard where indicated, then tack it to Santa's face. For the large Santa, satin-stitch the eyes with black embroidery floss, and the nose with red. For the small Santa, draw the eyes and nose with the fine-tip permanent marking pens. If Santa will be a hanging decoration, sew a loop of string at the top of his hat.

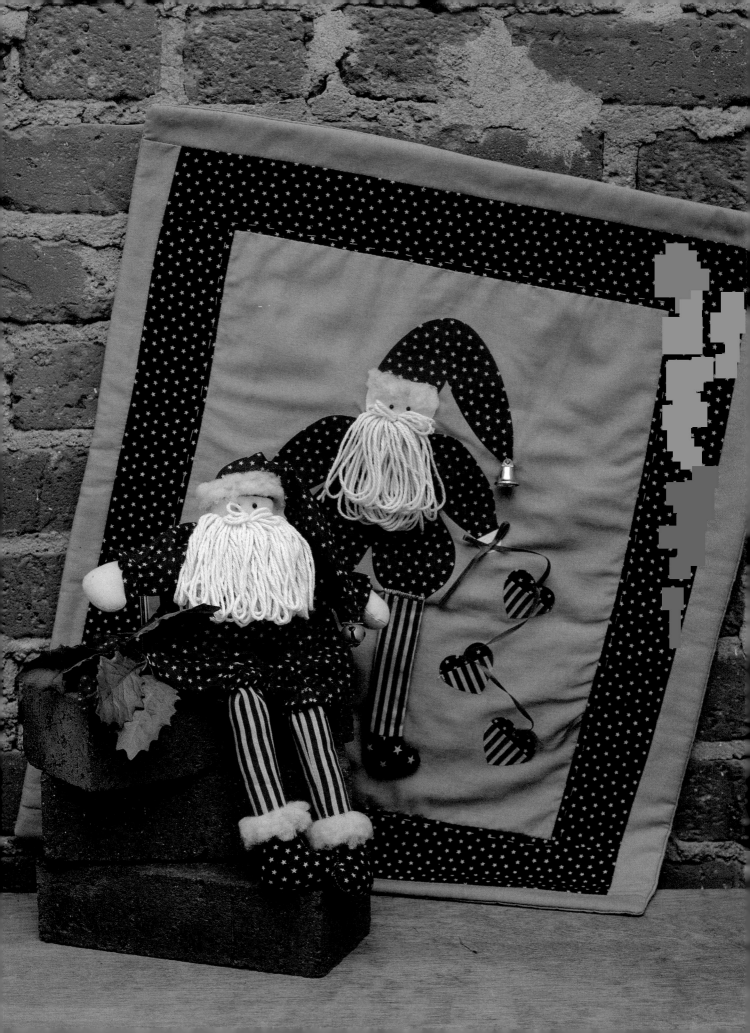

NICHOLAS DOLL AND WALL HANGING

A jaunty, long-legged St. Nicholas is captured in two festive works of whimsy. Each will add a cheerful touch to your holiday decorating. Together, they're a conversation piece. The Nicholas doll is about 12″ tall; the wall hanging measures approximately 18″ × 21″.

Supplies for the doll

¼ yd. of muslin for body and arms (tea-dyed, if desired)

6″ × 10″ piece of striped cotton fabric for legs

3″ × 10″ piece of dark-blue cotton fabric for feet

½ yd. of red cotton fabric for jumpsuit and hat

scrap of lamb's fleece (tea-dyed, if desired) for hat and boots

10 yds. of string *or* lightweight yarn for beard

2 black 3mm beads for eyes

matching thread for body and print fabrics

polyester fiber stuffing

powdered blush for cheeks, if desired

small jingle bell for hat

Supplies for the wall hanging

⅝ yd. of tan cotton for background, backing, and outside border

⅝ yd. of cotton *or* polyester batting

¼ yd. of iron-on transfer webbing

2″ × 4″ scrap of muslin for face and hands

5″ × 8″ scrap of striped cotton fabric for legs

¼ yd. of dark-blue cotton fabric for border and feet

5″ × 10″ scrap of red cotton fabric for suit and hat

scrap of lamb's fleece for hat

assorted scraps for hearts

½ yd. of ⅛″ ribbon for hearts

small bell for hat

3 plastic rings (¾″) for hanging quilt

small amount of polyester fiber stuffing for feet

2 black 3mm beads for eyes

matching thread for all fabrics

ecru quilting thread

To make the doll From the muslin, cut out 2 body pieces and 4 arm pieces. With right sides together, stitch around the body, leaving the bottom open. Turn

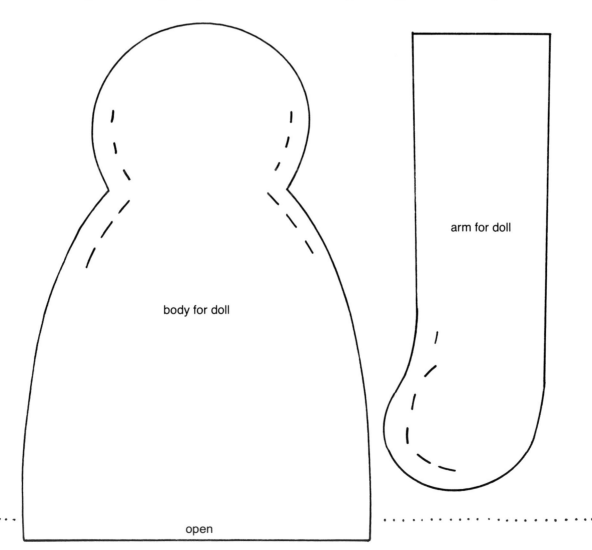

body for doll

arm for doll

open

right side out, stuff firmly, and sew the opening closed. With right sides together, stitch the arms, leaving the ends open. Turn right side out, stuff lightly, and sew them to the sides of the body.

For the legs, stitch a 3″ × 10″ strip of foot fabric to a 6″ × 10″ strip of leg fabric (right sides together), along the 10″ edges. Cut out 4 leg/foot pieces from this piece, being sure to reverse 2. With right sides together, stitch each leg, leaving the top open. Turn the legs right side out, stuff them firmly to within 2″ of the top of the leg. Leave these remaining 2″ empty. Machine stitch the legs to the bottom of the body.

open

leg/foot for doll
(cut 4, reversing 2)

seam

Santa's suit To make the full-size suit pattern, fold a piece of 9″ × 14″ (or larger) tracing paper in half widthwise. Place the fold of the paper down the center of the suit and trace the suit pattern. Cut out the paper so that it will be the size of the full front of the suit.

Place the shoulders of the pattern on the fold of the suit fabric and cut 1 suit piece. Cut 2 hat pieces from the same fabric. Press up (to the wrong side) ¾″ on the sleeve edges and on the leg bottoms. With right sides together, stitch the underarm seams and the crotch seam. Clip the curves and turn right side out. Fold the sleeves and pant legs under ¾″ and run a gathering thread around each. Fold under ¼″ at the neckline and run a thread around it. Put the suit on the doll, pull the threads, and secure them.

With right sides together, stitch the hat, leaving the end open. Turn it right side out, fold under ¼″ at the edge, and put the hat on Nicholas. Tack the hat all around the head. Then tack a ⅜″ × 4″ strip of fleece around the edge. Sew the jingle bell to the tip. Tack ⅜″ × 3″ strips of fleece around each seam where the leg meets the foot.

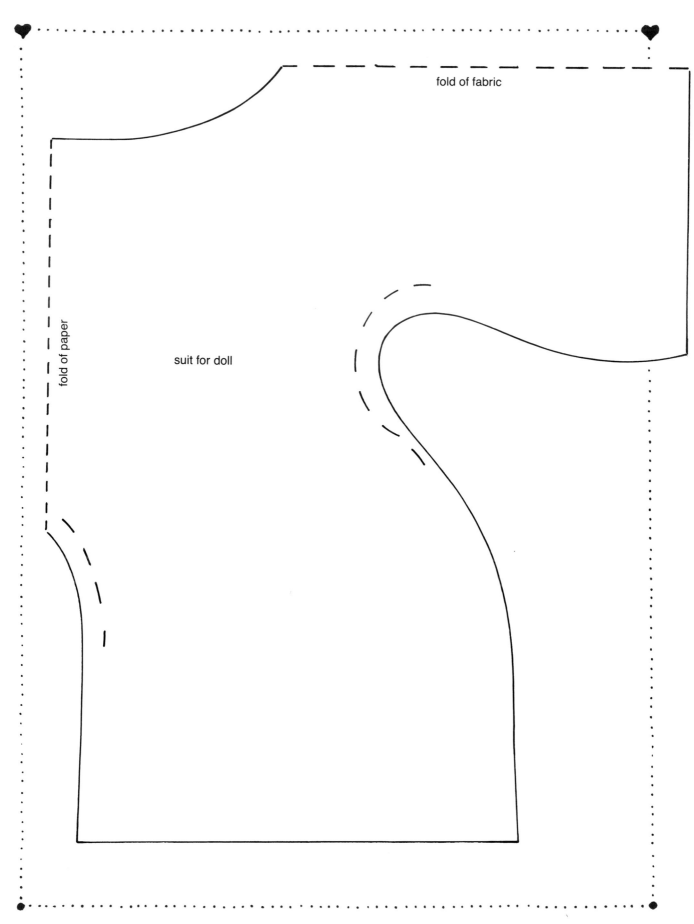

fold of fabric

fold of paper

suit for doll

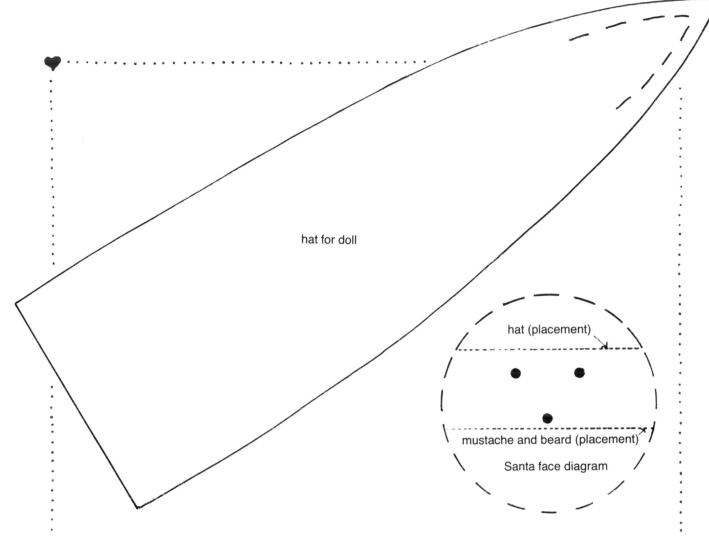

hat for doll

hat (placement)

mustache and beard (placement)

Santa face diagram

Face Sew the 3mm beads to the face for eyes and apply powdered blush to the cheeks, if desired. Make the beard by wrapping string around a 6″-wide piece of cardboard about 25 times. Carefully slide the string off, and stitch it across the center. At this seam, tack the string to the face. Make the mustache by wrapping string around 2 fingers, 3 or 4 times. Slide off the string, tie it in the center with string, and tack the mustache to the face.

To make the wall hanging Cut the background fabric to measure 12½″ wide × 15½″ long. Cut out 2 leg pieces and 2 foot pieces. With right sides together, stitch each foot piece to each leg piece. Fold the leg lengthwise, right sides together, and stitch up each side, leaving the tops open. Clip the curves, turn the legs right side out, and lightly stuff the feet only. Do not apply webbing to the legs.

Following the webbing manufacturer's directions, fuse the webbing to the scraps of fabric that will be used for the face and hands (muslin), and the suit and hat (red print). Cut out 1 face piece, 2 hand pieces, and 1 suit piece. Cut 1 hat piece on the right side of the fabric.

Sew a 1½″ × 5″ strip of striped cotton to a 1½″ × 5″ strip of different print fabric. Press the seam open and apply webbing to the back before cutting out 3 hearts. Lay out all the pieces on the background and arrange them as you wish, placing the legs under the ends of the suit pants. Following the webbing manufacturer's directions, press and fuse the pieces to the background.

Using the sewing machine's zigzag stitch, sew across the bottom of the suit to secure the legs in place. Tack a ⅜″ × 1½″ strip of fleece to the hat edge. Sew on the 3mm beads for eyes and apply powdered blush to the cheeks, if desired. Make the beard and mustache as for the doll, wrapping the beard about 20 times. Tack a bell to the tip of the hat and a ribbon to one hand and each of the hearts, as shown in the photograph.

To finish the wall hanging For the inside borders, cut 2 strips of dark-blue fabric 2½″ wide × 15½″ long. With right sides together, stitch these to the longer sides of the tan background. Cut another 2 strips of dark-blue fabric, this time 2½″ wide × 16½″ long. With right sides together, stitch these to the top and bottom of the shorter sides of the tan background piece, stitching over the side borders already in place. For the outside borders, cut 2 strips of tan fabric 1½″ wide × 19½″ long. Stitch 1 to each long side. Cut 2 strips of tan fabric 1½″ × 19″ and, with right sides together, stitch 1 to the bottom and 1 to the top. Press the quilt top.

Lay the quilt top on batting and cut the batting to size. Then lay the quilt on the tan fabric and cut a backing to size. Stack the backing and quilt top right sides together and stitch, leaving an opening at the center bottom for turning. Clip the corners, turn the quilt right side out, and press. Whipstitch the opening closed and, with quilting thread, hand or machine quilt around the inside border for a decorative touch. Tack 3 rings to the top edge of the back of the quilt for hanging.

hat for wall hanging

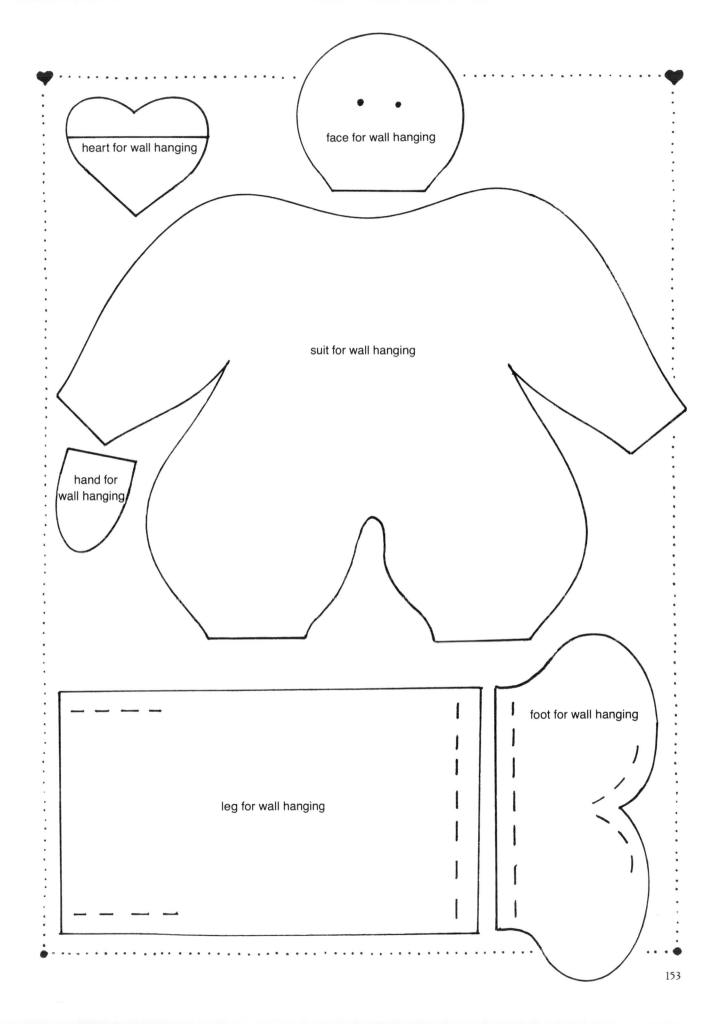

heart for wall hanging

face for wall hanging

suit for wall hanging

hand for wall hanging

leg for wall hanging

foot for wall hanging

153

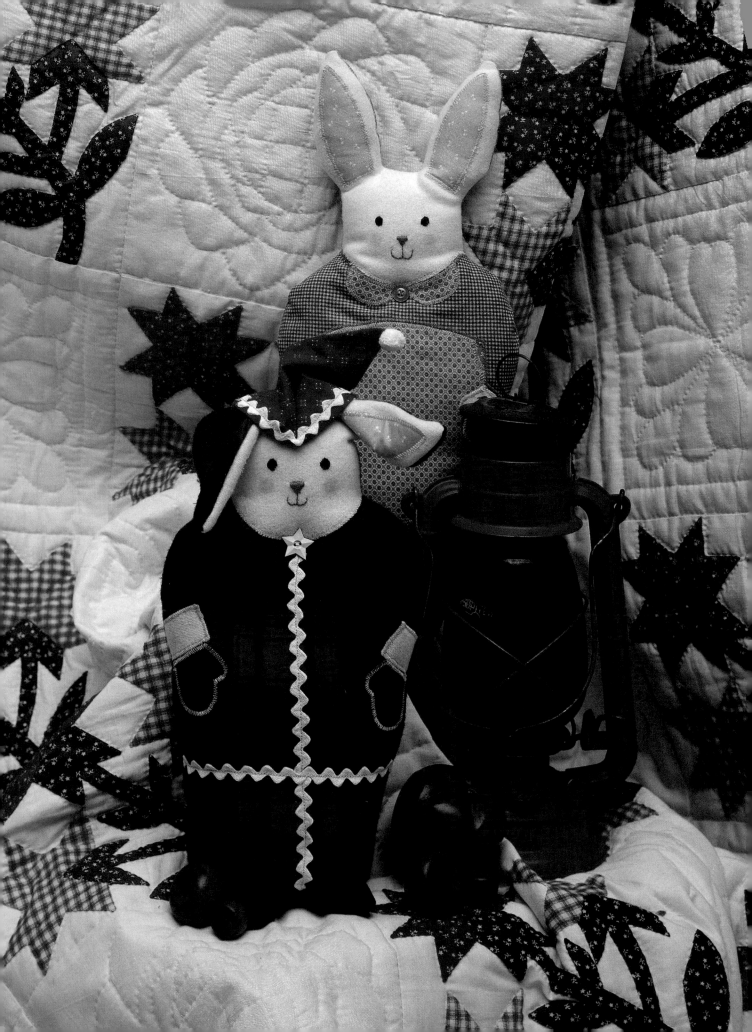

BUNNY DOORSTOPPERS

These doorstoppers are also showstoppers! Their well-stuffed shapes, appliquéd details, and endearing faces will hold your doors *and* your attention. Santa Bunny and Mrs. Bunny are 16″ tall.

Supplies for each bunny

♥ 9″ square of wool *or* muslin for head
4″ square of pink print cotton for ears
6″ square of black fabric for shoes
embroidery floss: black and rose for face
powdered blush for cheeks, if desired
polyester fiber stuffing
small plastic sandwich bag of sand *or* other weighted material

Santa Bunny ¼ yd. of red wool fabric for the body
4″ square of black fabric for mittens
7″ × 12″ piece of red print fabric for hat
1 yd. of ¼″ ecru rickrack
½″ pom-pom
star-shaped button
matching thread

Mrs. Bunny ¼ yd. of calico cotton fabric for body
7″ square of different calico cotton fabric for collar and apron
6″ × 9″ piece of different calico cotton fabric for blouse
½″ round button
matching thread

To make Santa Cut 1 body front piece on the fold, overlapping the pattern pieces where indicated. Cut 1 head piece on the fold, 2 cuff pieces from the head fabric, 2 mitten pieces, 2 ear pieces, 4 shoe pieces, and 1 base piece. You will cut Santa's back piece later.

With the right sides up, place the head piece on the body front piece, noting the placement line. Join these pieces by appliquéing the bottom edge of the head: zigzag over the edge with tightly placed stitches. Cut away any excess fabric from the top of the body in back of the head. Place the constructed head and body face down on the right side of the remaining body fabric, trace around it, then cut out the body back piece. Set the body back aside.

Sew rickrack down the center of the Santa suit. Appliqué the ear linings in place, then appliqué the mitten and cuff pieces in place on the suit front. Place another length of rickrack horizontally across the suit, just below the mittens, and sew.

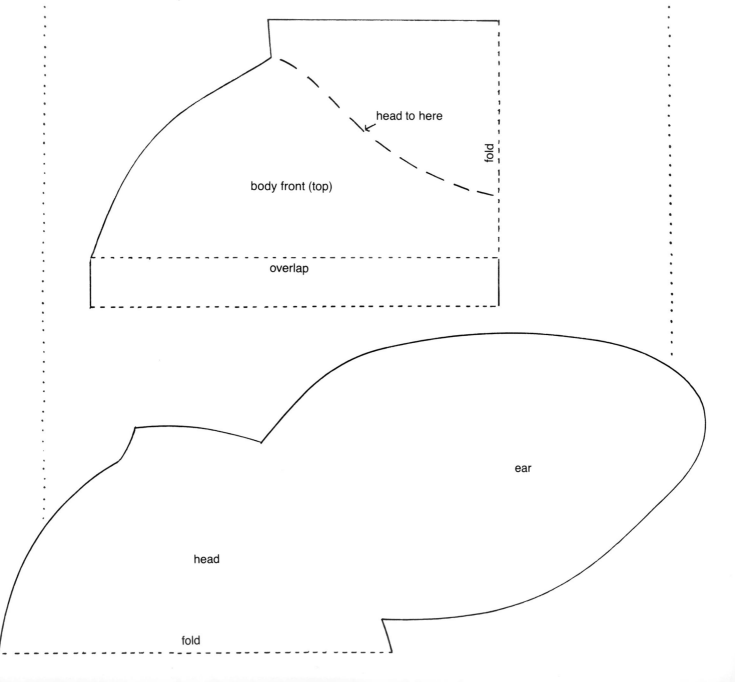

head to here

fold

body front (top)

overlap

ear

head

fold

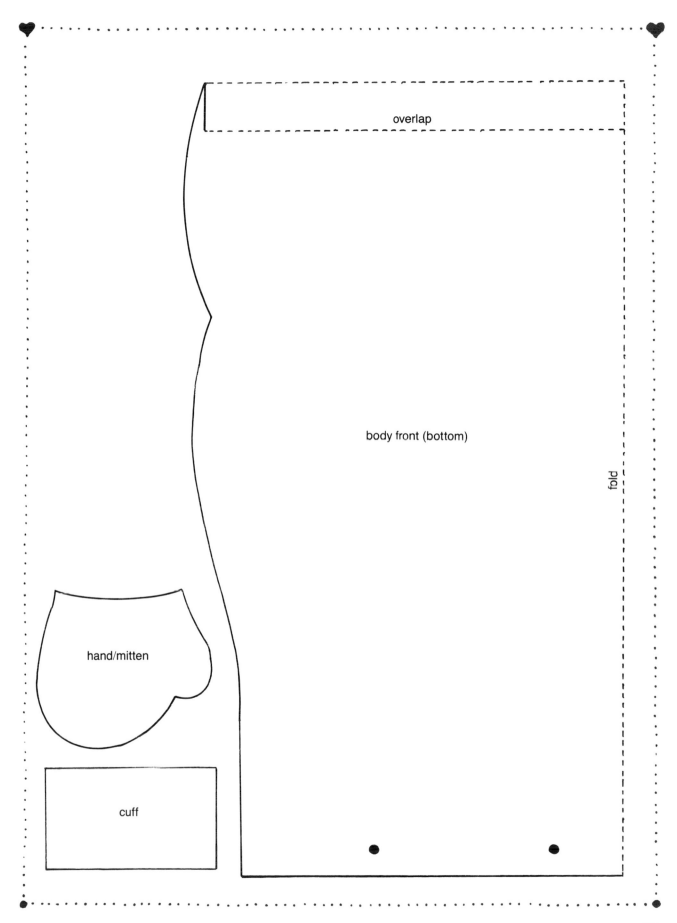

overlap

fold

body front (bottom)

hand/mitten

cuff

With the right sides together, sew the foot pieces and pin them to the bottom of the body front. Sew around the body and the ear pieces (right sides together), leaving the bottom open and another opening on the side for turning and stuffing. Again with right sides together, stitch the base to the bottom of the doorstopper. Clip all the curves, turn Santa right side out, and place the weight in the bottom. Stuff the remaining area plumply, but do not stuff Santa's ears. Close the opening.

Using 3 strands of floss, satin-stitch round eyes in black, satin-stitch a triangular nose in rose, and backstitch the mouth in rose. Apply powdered blush to the cheeks, if desired.

For the hat, cut out 2 hat pieces on the fold. Fold the lower edges ¼″ to the wrong side of the fabric twice and topstitch. Lay rickrack on the right side of the hat and topstitch all around. With right sides together, sew the hat pieces together. Turn the hat right side out and sew the pom-pom at the tip. Place the hat on Santa's head, pulling the ears down, and tack the hat in place. Sew the button to the top of the suit, just under Santa's chin.

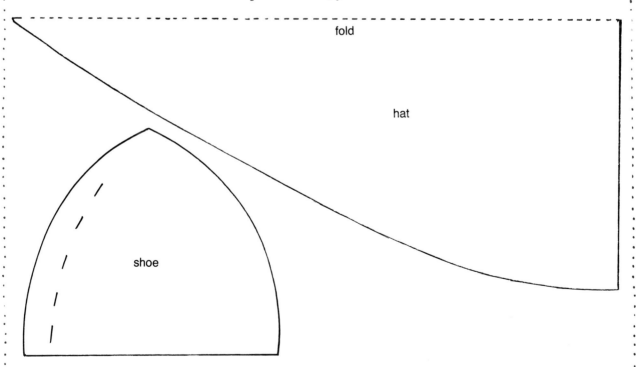

Mrs. Bunny Cut 1 body front piece on the fold, overlapping the pattern pieces where indicated. Also cut 1 head piece, 2 hand pieces (from the head fabric), 1 blouse piece, 1 apron piece, 2 collar pieces, 2 ear pieces, 4 shoe pieces, and 1 base piece. You will cut the back piece later.

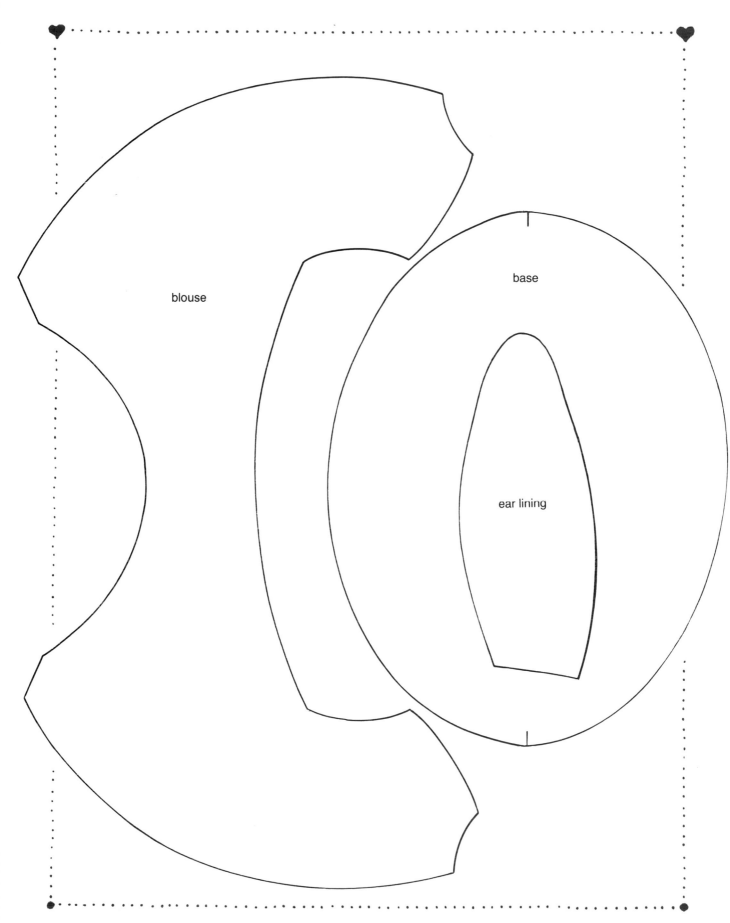

blouse

base

ear lining

Assemble Mrs. Bunny as you did Santa, but appliqué the blouse piece to the body piece first. Next appliqué the apron piece, the collar piece, and then the hand pieces. Appliqué the ear lining pieces to the ear pieces. Lay the finished front on the remaining body fabric, and cut out the body back piece. Finish as directed for Santa, but stuff the ears this time when stuffing the body. Sew the button to the collar, just under her chin.

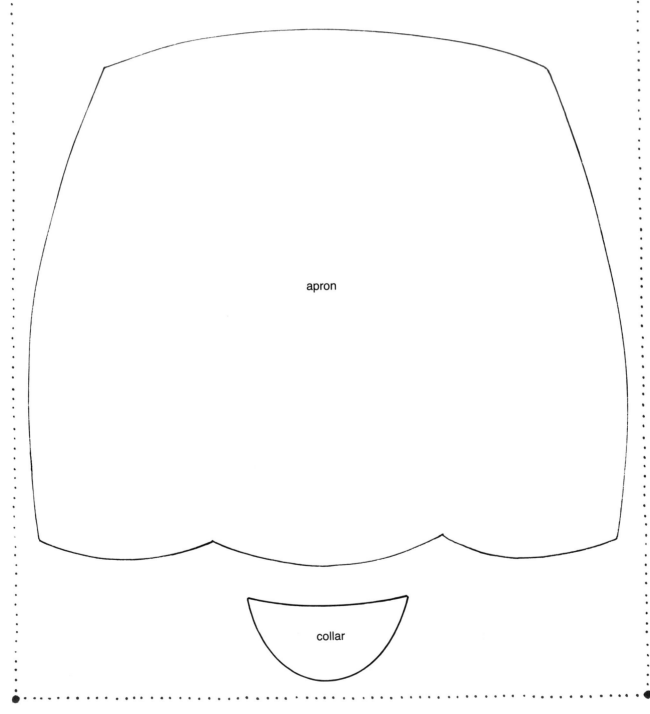

apron

collar